DAILY PAINTING

Paint Small and Often to Become a More Creative, Productive, and Successful Artist

CAROL MARINE

WATSON-GUPTILL PUBLICATIONS
Berkeley

For Bren

Text and photographs copyright © 2014 by Carol Marine

Published in the United States by Watson-Guptill Publications, an imprint of
the Crown Publishing Group, a division of Random House LLC, a Penguin
Random House Company, New York.
www.crownpublishing.com
www.watsonguptill.com

WATSON-GUPTILL and the WG and Horse designs are registered
trademarks of Random House LLC

All photographs are by the author except as noted in the Acknowledgments

Library of Congress Cataloging-in-Publication Data
Marine, Carol.
 Daily painting : paint small and often to become a more creative,
productive, and successful artist / Carol Marine.—First Edition.
 pages cm
1. Painting—Technique. I. Title.
 ND1505.M36 2014
 751.4—dc23
 2014009131

Trade Paperback ISBN: 978-0-7704-3533-2
eBook ISBN: 978-0-7704-3534-9

Printed in China

Design by Michelle Thompson | Fold & Gather Design

12

First Edition

DAILY PAINTING

Contents

Acknowledgments

I couldn't have written this book without help from others. My family encouraged me to follow my dreams, and put up with me through the tough bits where I may have yelled a little bit (sorry). My students served as guinea pigs for all the lessons and exercises you'll find herein (don't listen when they say I threatened them with push-ups if they didn't cooperate!). My fans kept my spirits high with comments and emails. My friends helped me with kind words, warm shoulders, and plenty of wine. My generous collectors kept me housed and fed, and all the kind folks at Ten Speed took my ramblings and made them into a real book! In the end it was a group project, and I thank you all from the bottom of my heart.

Special thanks to all my contributing artists: Roger Åkesson (page 19), Christine Bayle (page 52), Carmen Beecher (page 57), Kara K. Bigda (page 34), Bruce Bingham (pages 153–55), Brian Burt (page 102), Elizabeth Chapman (page 57), Randall Cogburn (page 40), Crystal Cook (pages 150–52), Laurel Daniel (page 104), Lisa Daria (page 56), Belinda Del Pesco (page 46), Erin Dertner (page 53), Jelaine Faunce (page 16), Brenda Ferguson (pages 144 and 146), Jacqueline Gnott (page 36), Claudia Hammer (page 175), Catherine Harley (page 44), Clinton Hobart (page 86), Diane Hoeptner (page 43), Qiang Huang (page 62), Barbara Jaenicke (page 39), Karin Jurick (pages 18 and 103), Oriana Kacicek (page 62), Elena Katsyura (page 94), Duane Keiser (page 4), Rita Kirkman (page 42), David Lloyd (page 133), Raymond Logan (page 35), Jo MacKenzie (page 52), Nora MacPhail (page 172), Felicia Marshall (page 47), Michael Mikolon (page 48), Patti Mollica (page 133), David Morris (page 17), Michael Naples (page 50), Julie Ford Oliver (page 35), Cathleen Rehfeld (pages 119, 147–49), Kimberley Santini (page 105), Sarah Sedwick (page 96), Dean Shelton (page 41), Nadi Spencer (page 42), Randall David Tipton (page 55), Dreama Tolle Perry (pages 20 and 105), Victor Tristante (page 33), Donna Walker (page 169), Joyce Washor (pages 156–58), Kathy Weber (page 45), Robin Weiss (page 39), Cietha Wilson (page 14), and Liz Wiltzen (pages 140, 142–43).

Introduction

Early in my painting career, a professional artist I admired advised me to paint every day. He said it was the only way to get any better. I promptly ignored his advice and continued to coast as a starving artist for years.

But in 2006 all that changed. That was when I discovered daily painting—a movement that encourages artists to create one small painting nearly every day, and sell that work online. Before daily painting, I was in a frustrated rut. But after that epiphany in 2006, I not only improved my skills rapidly, I launched a successful art career and a website, dailypaintworks.com, that is quite popular. And now I am proud to say I am no longer starving!

While the idea of painting *every day* may sound overwhelming, let me assure you, there are no specific rules or requirements. Really when I say you should paint "daily," I mean you should paint "often"—but "Artists Who Paint *Often*" wasn't catchy enough to jump-start a whole movement! Sure, the *ideal* might be that you paint every day, but not many of us can commit that much time to art, so we must settle for as often as we can. The daily-painting movement encompasses artists who paint daily, weekly, monthly, or intermittently. What ties these artists together, and qualifies them as "daily painters"? The simple fact that they strive to paint frequently, without getting bogged down by perfectionism, procrastination, or any of the myriad things that keep us out of the studio.

The benefits of painting often are *huge*, as are the advantages of making small art (though not necessarily *only* small). We learn just as much about composition, color, paint application, value, and so on in one hour with a small painting as we do toiling for weeks on a larger one. And because it only takes an hour or so, we can fit it into our busy schedules and we aren't heartbroken (and/or broke) if it doesn't work out. We can then apply the knowledge—and, if our painting is a success, the confidence—we've gained to larger work.

"Small" art means different things to different artists. A lot of daily painters (including me) are in the habit of doing a lot of 6 by 6-inch paintings, but this is absolutely not a requirement. Some artists feel more comfortable turning out tiny paintings, some like larger surfaces, and still others do a wide variety of sizes, depending on the subject, day, and so on.

There are also no requirements in terms of media or subject matter. Daily "painters" use anything from oil to pastel to collage to charcoal and more.

Rose Glow, 6 x 6 in., oil on board, 2012.

They paint a huge variety of subjects from still lifes to portraits to cityscapes to cats to completely abstract and beyond. The great thing about doing lots of little paintings is that you can try everything! You can do three little oil paintings of apples today, a portrait of your dog tomorrow in pastel, two versions of the tree in your front yard in watercolor the next day, and on and on. The fun never stops!

Most daily painters use a blog to document their progress and showcase their work. A blog is easy to set up, free, and a cinch to update. Even if you blog just for yourself, with no intention to sell, the connections you can make with other artists are amazing! Too often, we artists work all day alone in the studio, with only our spouse, kids, or animals to give us feedback. And while they mean well, they don't always have the most encouraging things to say. My (least) favorite from my husband is, "Is it done?" But I get comments on my blog every day from people (mostly artists) who give me positive feedback that keeps my spirits high.

These connections have also brought about huge opportunities for my career. I got my first invitation to teach six months after I started blogging and now get so many, I have to turn most of them down.

In a time when galleries are closing all around us, the Internet offers a new, exciting venue for artists. Our potential market is the whole world, while galleries rely mostly on foot traffic. We are more in touch with our buyers, which gives us a better understanding of our market. Best of all, we skip the high gallery commissions and so do our buyers!

This book is a chance for me to share with you all the valuable lessons I've learned from painting daily: from materials to color mixing to ignoring your brain to photographing your art to marketing yourself online. I've also included lots of examples of other artists' daily paintings to inspire you as to what's possible in terms of medium and subject matter.

I have been happily painting daily since 2006 and don't intend to stop. If you are serious about improving your skills, increasing your sales, and expanding your network of artists, I recommend you do the same!

How Daily Painting Changed My Life (and Can Change Yours Too!)

My Story

I grew up in a small Texas town in a geodesic dome house with chickens, goats, an outhouse, and a very creative family. Our parents encouraged us to follow our dreams. They said we might never be rich but we would always have enough to live on if we did what we loved. And we would be happy. Art was in my blood from the time I was tiny, so I set out from high school to the University of Texas in Austin to learn more about it.

Unfortunately, my education at the university was seriously lacking. My professors were more interested in discussing the politics behind the art than any kind of technical skills. I never once heard a lecture about value, composition, or color theory, much less how to *sell* art.

Hannah, 30 × 36 in., oil on canvas, 1999. My favorite painting from college, a portrait of my cousin Hannah.

One of the things I did learn in college is that you're not a "real" artist unless you paint large, make all your own stretchers by hand, and stretch and prime all your canvas. Needless to say, this takes a lot of time. So when I would finish a painting that took me two weeks, start to finish, and it was terrible (because I didn't learn anything about actual painting in college), I was heartbroken.

I found myself waking up every morning thinking, "What should I do today? Should I go into the studio and do another bad painting or . . . clean the house?" And more often than not, I would clean the house or do *any* other task that would help me avoid the studio. The more I avoided the studio, the more riddled with guilt I became, and so I was doubly depressed. Here I was, following my dream, which was supposed to make me happy—but it wasn't.

The hours I actually spent painting came and went. I tried to focus on painting portraits and did some for friends and neighbors to build up a portfolio. One day on a whim I wrote to one of my favorite portrait

artists, Michael Shane Neal, for some advice. A couple of weeks later I was shocked to receive a three-page handwritten letter, chock-full of great information. At the end of this letter, Michael wrote, "The best way to improve your skills is to do some kind of art every single day." I thought, "Yep, heard that before," and continued to ignore the best advice I'd ever receive.

What followed were years of struggle. I continued to paint whenever I felt guilty enough, but used every excuse to get out of the studio. I did crafts with my two young stepdaughters. I tried switching to web design for a couple of years. Unfortunately it was right *after* the dot-com bust (what was I thinking?!), and I never found a foothold. Over the years, I apparently ended up getting into the studio often enough to build my skills somewhat and teach myself some basics. My style was tight, I was still doing large paintings, and a fair number still didn't turn out well, but I was slowly getting better.

Maddie, 44 × 32 in., oil on canvas, 2002. A portrait of my stepdaughter, Maddie, when she was six years old.

One day I decided to set a new goal. I gave myself six months to do ten (hopefully) fabulous paintings that I would take to my favorite gallery in town. If they didn't take me in, I would find another career. I was considering learning to cut hair.

So I did my ten paintings and took them to the gallery. The owner was very distracted and took her time looking over my work but in the end asked me to leave a few behind. She called me on my way home to say she had just sold one! So I started painting full-time, for the gallery. Unfortunately, I was hit by the same dilemma as before: maybe one out of every three paintings was salable, and the others were costing me a lot of time and money. I made enough to cover the cost of my supplies but nothing close to a living.

Blue Monday, 22 × 64 in., oil on canvas, 2004. One of my first gallery paintings, of a scene in downtown Austin—I did a lot of cityscapes then.

After a while, I found myself making excuses again. I had all the time in the world and yet was only getting into my studio a couple of days a week. At about the same time, my husband and I adopted our son, Jacob. This gave me the best excuse of all: *I can't paint—I have to take care of the baby!*

When our son was about a year and a half, a friend sent me an article about daily painting. The concept first gained prominence with artist Duane Keiser who was in a similar position to mine (minus the child). He was selling some work in galleries, but not enough to live on. Along the way, someone suggested he do small studies for his large paintings, and one day he decided to throw a party, invite everyone he knew, and sell his

Pink Flower in Jar, 34 × 40 in., oil on canvas, 2004. Another of my first gallery paintings—I did a lot of these big flowers in jars.

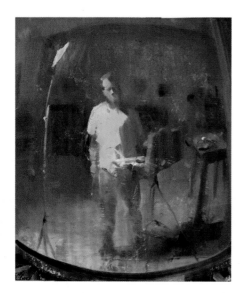

Duane Keiser, *Self-Portrait in a Convex Mirror*, 7 × 6 in., oil on paper, 2013. Duane is considered the father of daily painting.

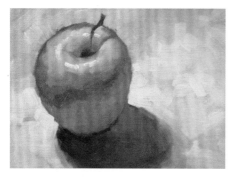

Apple, 6 × 8 in., oil on panel, 2006. My first daily painting.

small paintings for $100 each. This was a big hit, so he took it to the Web. He created a blog called *A Painting a Day* and listed each small painting on eBay, starting at $100. Suddenly he was making a living, and other artists were catching on to the idea.

When I told my husband about it, he said, "You should do this!"—but I had my doubts. Surely I would fail at this as I had with everything else. But he kept poking and prodding me, saying, "C'mon, you've got nothing to lose." So I ordered some small panels, and one day, when our son went down for a nap, I took out my paints, set up some onions, and painted them. It was in the same tight style I'd always worked in, took two full hours, and I *hated* not only the result, but the process as well. I don't have a picture of it to share—I wiped it off immediately after.

The next day, I decided *not* to repeat the experience. But once again, I had the expanse of nap time and all the panels, so I painted anyway, attempting a style I'd always wanted to try but didn't have the nerve to on one of my big, expensive, stretched canvases. What *did* I have to lose?! I set up a simple apple and after about twenty minutes, wiped that panel as well. After that I just played. At the end of nap time I had something I was pretty happy with. It wasn't a masterpiece, but it went in a direction I was excited about. Painting it had been fun, and hey—I had accomplished something worth sharing in little over an hour!

When my husband got home from work that day I was bubbling over with excitement. I said, "I get to do this again tomorrow! And the next day!" Suddenly my future was looking brighter.

Painting small and often gave me the freedom to experiment—every day I got to start on an entirely new project. No longer did I feel overwhelmed by the large number of things I wanted to paint—I could do them *all*. And I could do each one fifty different ways (or more)! If one subject or one style didn't quite work out, well, I didn't sweat it. I had only invested part of a day's worth of work on it, after all.

My fear of failing disappeared—well, *almost*. Probably a little fear is good for us. I *do* know I was no longer making excuses not to paint, and I woke up every morning genuinely excited and eager to get into the studio. My depression was gone.

In less than a year, I had done a staggering two hundred paintings— more than the total number I'd done in the previous five years combined. Because I was posting my paintings on a blog, in sequential order, I could

Umbrella Flower, 6 × 8 in., oil on panel, 2007. Daily painting #200.

easily look back to the beginning and see progress. I found in those two hundred paintings I had grown *more* than in the *five* previous years!

Fortunately, because I was painting during my son's naps, I had a set time every day that I *had* to paint—or not at all. This lent structure to my routine. Because I was posting each painting on my blog, I had created a commitment for myself. If I missed a couple of days, I got emails from people saying, "What's wrong? You haven't been posting!" Okay, most of those were from my mother at first, but that still counts.

Previous to daily painting, after spending days or weeks on a large painting, I had a hard time being honest with myself about whether or not it was worthy of being sent to the gallery. If it wasn't, it was devastating, and after that much work, I did everything I could to convince myself it *was* good, even if I was deluding myself. With the small paintings, each panel costs about $1 and takes one to three hours to paint. I find I can easily say to myself, "This one simply didn't work," wipe it off, and start over. Or I often do a series of one subject, getting better each time. I am much less emotionally attached to each painting, even the larger ones, and can survive a scathing critique with much more grace than before . . . most of the time, anyway (don't talk to my husband about this!).

Because less ego is involved with each piece, I can enjoy the process of painting more fully. I have more confidence in myself as an artist, which has carried over to other aspects of my life.

After a few months of painting daily, I started to explore the marketing aspects of this new business. I joined an online gallery, listed my paintings on eBay, and traded links with other artists (more about this in chapter 11). Finally, I started to sell a few paintings from my blog. It was slow at first, very slow, but gradually I was selling more and more of my paintings, and some were even being bid up. I was making a (modest) living in a world where earning your way as an artist can be tantamount to climbing Mount Everest!

At this time a lot of other artists started jumping on the daily painting bandwagon. They were all creating blogs, using mostly the same free service—Blogger (blogspot.com). It has a feature that allows others to comment on each blog post/painting. A huge community of daily painters has now formed (and is growing all the time), all commenting on each other's art. Whereas most artists find their work a solitary experience, we have found a new venue in which to share our art with each other (and the world). I can't tell you what a boost it is to post a painting and within hours get comments and feedback from other artists about what I've created!

Big Bottom, 6 × 6 in., oil on panel, 2007. Daily painting #345.

After about six months, I got my first invitation to teach a workshop. After I posted about it on my blog, I very quickly got my second invitation. A guy from Sacramento called me and said, "I see you're teaching in Santa Fe. Do you think you could do the same thing for us here?" Before long I was getting invitations to teach more workshops than I could say yes to, all around the continent and the world! Because I had been painting every day and my skills were growing rapidly, I felt confident this was something I could do. Before daily painting, I would have laughed at the idea.

A year into daily painting, I was selling fairly well, but I wondered what I could do to market myself better and get to the next level. I thought about print advertising, but the prices were exorbitant. In 2008, with the help of my programmer husband, I decided to start an online gallery with other artists to pool our resources and advertise. Thus, dailypaintworks.com was born. At first we had just twelve members, and together we paid for a monthly, quarter-page ad in *American Art Collector*. We stayed that way for about four years.

In 2010, my husband lost his job, and we decided to focus on Daily Paintworks and make it into something great. We incorporated an auction feature into the site so our artists could manage without eBay's high fees and then opened the membership to *any* 2D artist—daily painters and not—wanting to sell original work.

We basically used everything I had learned about how to make daily painting successful and applied it to Daily Paintworks. Though the site isn't juried, we have an amazing community of artists, and each posts as frequently (or infrequently) as they want. Whatever they post on their blog is automatically pulled and shows up on the front page of Daily Paintworks for one day (and in the archives forever), with a buy link and a way for buyers to see it larger, and then is cataloged in their personal gallery. We've gradually added features like weekly challenges, a monthly contest, a place to exchange critiques, the ability to give and receive public comments, a grid to track sales and unsold paintings, an online tutorial section called ArtBytes, and more.

During the first few years of daily painting, I also sold larger work in galleries. The galleries worried that my auctions would undercut their sales, so I had to assure them that the two worlds were separate. To that end, I sold only paintings larger than 8 by 10 inches in galleries and only paintings smaller than that online. (In retrospect, I probably could have moved away from the gallery model entirely—but it was so ingrained in my mind as "the way" the art world works, I had trouble letting go of my existing gallery relationships!) Because of my website and my platform,

Breakfast, 6 × 6 in., oil on panel, 2009. Daily painting #705.

Royal Procession, 6 × 6 in., oil on panel, 2010. Daily painting #997.

I brought new customers to the gallery—and similarly, the visibility of being displayed in galleries meant that they brought new customers to my site.

Ultimately, I found that every year I brought in three to four times as much in online sales as from galleries. Of course, this varies from artist to artist—for some, gallery sales are a significant percentage of gross sales. But in my case, after having to hassle several galleries for payments, I decided to pull out of them completely and sell large *and* small work online. I end up charging less for each painting, but I sell every single one, and I (almost) never have to hassle anyone for payment.

Even though I have sold a number of larger paintings online, I find that smaller work sells better there, in general. People are less willing to spend large amounts of money on large paintings they can't see in person than they are to spend a small amount for a small painting that is easy to see well enough on a computer screen.

I've been daily painting now for more than six years, and it has completely transformed my career and my life. A friend of mine once implored me to spill my secrets as an artist and just tell her what to do, so she could instantly improve. But there aren't any secrets. It's like we've all got a painting muscle, and we've got to work it out, as often as possible, to get better and stay better—just like exercise. If that's a secret, then it's the only one I know!

Benefits of Painting Small and Often

I've shared my own personal story—and I am living proof that daily painting can turn your life and career around. But if you're still not completely convinced, let me lay out the pros of switching to the daily painting model:

- **It fits into your busy schedule.** We have busy lives. We've got jobs and chores and family to spend time with, and it can be daunting (to the point of endless procrastination) to think of fitting art into all that. But if you can find a corner (and it can be a small one, since daily painting shouldn't take up a lot of space), have your stuff always set up, and get in the habit of producing one small painting each day that may take an hour to complete, the idea is far less daunting.

- **You're more inspired to experiment.** When you're only doing large works, you often feel a compulsion to get things "finished," especially if you are delivering them to a gallery or show. With this mentality, it can be difficult to do any kind of real experimenting. But with small

Surprise, 6 × 6 in., oil on panel, 2012. Daily painting #1677.

Intimidating, 6 × 6 in., oil on panel, 2011. Daily painting #1307.

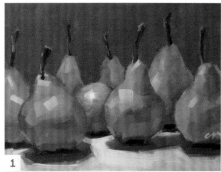

To illustrate the quick growth that comes from daily painting, here are two pear paintings of mine; the first from year one, the second from year four. **1.** *Surrounded*, 6 × 8 in., oil on panel, 2007. **2.** *Coming or Going*, 6 × 6 in., oil on board, 2011.

paintings that take only an hour or so, you can try several new things every day.

— **You're less emotionally involved.** When you spend days or weeks (or more) on one painting, it can be a crushing blow if it doesn't work out. When you are painting every day and doing mostly small work, you quickly lose that sense of preciousness for each painting. It becomes much easier to say, "This just didn't work—but this next one might!"

— **It facilitates quick growth.** One day you paint and you have an idea for how it could have gone a little better. The next day you try out that idea, but you decide to make a little adjustment. So the next day you try that and so on. When you paint once a week or month, you often don't remember what worked and what didn't from the time before, so in a way, you're starting over each time.

— **You feel less fear.** When you know you will be working on a large painting for a while, there is often a lot of pressure to make that one painting a masterpiece—and fear that it won't be. With small, quick paintings, there is much less pressure, which ends up alleviating a lot of the fear involved.

— **You enjoy the process more.** When you're doing lots of little paintings, it's much easier to get into a groove and enjoy the actual painting process. You realize quickly that not every painting works out but that you keep getting better, and it's that challenge of improving that makes painting so enjoyable!

— **You gain confidence.** As you get better, and more of your paintings work out, you develop more confidence in your ability. You may even be able to fathom the idea of doing a demo or teaching a class.

— **It's less tedious.** With a large painting, there are often areas that are quite tedious to paint, for example large areas of background where you think, "Heck, I've got to cover that whole area with this tiny tube of paint *and* make it look interesting!?" With a small painting, a comparably large area generally takes just a few brush strokes.

— **There's more structure.** If you expect to do one painting (or more) every day, this lends a certain structure to the life of an artist that we sometimes lack. When we have all the time in the world and no expectations, we tend to procrastinate. Does that sound familiar?

— **It helps your larger work.** Best of all, when you *do* decide to tackle larger paintings, you'll get to apply all the lessons you learned from the smaller ones.

Benefits of Blogging and Selling Online

Painting small and often is just one piece of the puzzle. Almost equally important to my own success was building an online network of similarly minded daily painters, who helped critique my work and support me as an artist. There are so many benefits of blogging and selling online:

- **There's a huge, supportive community.** There are thousands of artists painting often and posting to blogs. Most of them are very nice and leave lovely comments for each other. It is a nice way to share with others and get feedback about your work. Our friends and family, though they mean well, don't always know the best things to say.

- **You can avoid the middleman.** Most galleries take a 50 percent commission. While they do a lot (including paying rent), with the Internet we have a new opportunity to sell that is more direct, includes less overhead, and requires a lower commission. Yes, there are costs associated with selling online, but they are *much* lower than 50 percent—generally closer to 5 to 15 percent.

- **There's no gatekeeper.** You don't have to convince anyone to let you show online but you do to show in a gallery. Anyone can be a daily painter!

- **With auctions, the market sets the price.** Ever tried to price your work? Do you hate it as much as I do? When you sell with auctions, you choose the starting price and the market determines the end price. Your prices may start out low, but as you establish yourself and improve, they will steadily grow.

- **There's a huge potentional market: the world!** With brick and mortar galleries or art fairs, you are relying on foot traffic and word of mouth. With an online store, your potential market is anyone with a computer and Internet access! Again, your exposure may start out slow, but if you stick with it and continue to improve, the world is your oyster!

- **You'll get noticed.** I had the crazy notion when I was young that at some point I would be "discovered." Ha! The reality is that you will never be discovered if you don't put yourself out there. When you start posting regularly to a blog or website, people start to notice. Usually this happens slowly, so be in it for the long haul.

- **You encounter new opportunities.** When you put yourself out there, you run the risk of being asked to demo or teach. While this may sound scary, after a few years of daily painting you may well be ready for this, as I was. Teaching is a wonderfully fulfilling endeavor.

Two of my tomato paintings; the first from year one, the second from year five. **1.** *3 Tomatoes*, 6 × 8 in., oil on board, 2007. **2.** *Cherry Tomato Goodness*, 6 × 6 in., oil on board, 2012.

My Daily Routine

During every workshop I teach, someone always asks what my daily routine looks like. Do I really complete a painting every day? And if it only takes an hour or two, what do I do with the rest of my day?

My routine has changed a lot over the last seven years. At first I could only paint during my son's naps. After I started making money I could afford a babysitter to come a few days a week, and I used the whole time to do as many small paintings as I could so I could post something on my blog on the days I couldn't paint.

When my husband lost his job in 2010, he was able to watch our son and I was suddenly able to paint full-time. Some days I would do a bunch of small paintings so I could get ahead. This made it so I could still post daily when I was teaching or sick or simply needed a break. Other days I would do larger paintings for the galleries.

If I have all the time in the world to paint I tend to do everything else *first*. I check my email, do the dishes, make the bed (okay, that's a lie), water the plants, and so on. I find I work much better with a hard-and-fast start time like I had when I painted during my son's naps. My goal these days is to start no later than 10 a.m. That gives me time to eat breakfast, exercise, and take care of any other small chores.

Here are a few tricks for making sure your painting time is uninterrupted:

- **Call it work.** When I'm ready to start painting I say, "I'm off to work!" even though my studio is in the next room. This lends legitimacy to what I do, and while my husband has always been very supportive of my painting, it helps remind everyone that my painting is my livelihood—and that I really need time to focus.

- **Turn off my computer.** After I'm done with a basic email check, I shut my computer off completely. The only time I don't do this is if I'm doing a painting from a photo on my computer, in which case I close my email program (and Facebook) so I'm not tempted.

- **No phone calls.** I never answer the phone when I'm painting unless it's my son's school. Everyone else can leave a message, and I can *maybe* call them back later.

- **Listen to music.** I know listening to music while working isn't for everyone, but it helps me get into a groove. I even bought myself some cordless headphones so I can escape into my little world when there are distractions in the house.

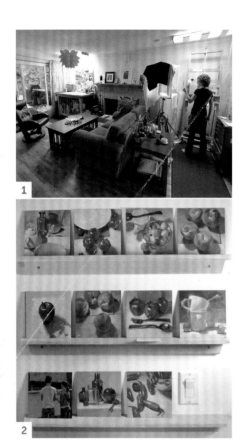

1. Me in my studio, Eugene, Oregon, 2013. **2.** My daily painting shelves, created and installed by my handy husband.

Another question I am often asked in workshops is, "How much time do you set aside for the nonpainting, business part of your work?" I read a book a long time ago about art marketing, and it suggested that the average artist spends 50 percent of his or her time on art and 50 percent on business. That may seem like a lot of time spent on "business"—but counting research and the like, I've found that the breakdown is about right.

Every afternoon I take a picture of my painting for the day. This takes about two minutes. Keep in mind I do this every day, so I have a routine that makes it easy (I'll talk more about that in chapter 10). Then I load the picture onto my computer and edit it (more on that later too). That takes maybe three minutes. Then I post to my blog. This takes a little longer—anywhere from five to thirty minutes—because I agonize over what I say there. Then I create an auction for my painting (one minute). Then I ship off any paintings that have sold (about twenty minutes per painting).

Hopefully this doesn't seem terribly taxing so far, because it doesn't seem like it to me. The rest of my "business" is mostly what I call "research and development." Research can be anything from cruising the Internet (for example, the website Pinterest) for other art I like and can be inspired by, flipping through art magazines and books, wandering around town taking pictures of things I might paint later, making trips to other cities for the same, and so on. Development is when I am experimenting with materials, taking workshops, shopping for props, and so on. I also include networking in this, and that includes corresponding via email, meeting and hanging out with artist friends, sharing ideas, swapping stories, and so on. What a job, eh?!

Well, sometimes it *can* be a job. Don't get me wrong. Every once in a while, I hit a creative block that knocks me off my tracks. This often happens when I have pushed myself *too* hard to create, as if I were a machine—when I have been scraping the bottom of the barrel for too long and not given it time to refill.

Artistic blocks have been such a significant problem for me that I have devoted chapter 9 to them. For now let me just say, it has changed my daily routine somewhat. The first thing I ask myself now when I wake up in the morning is, "Am I excited to paint today?" The answer varies, but more often than not it is, "Yes!" If I *don't* feel like painting, I do something else instead, even if that means going for a hike, reading a book all day, or just sitting or lying somewhere and getting totally bored. Those are some of the best things for refilling my tank, and I use them whenever I need them, without guilt, because I know if I don't, I risk a bigger burnout.

The sign on my studio door that lets my family know when I am working.

Expectations

I had a student call me once about three months after she took my workshop. She had only been painting for a few months *before* the workshop, so, total, she was on maybe month six. And she was frustrated with her progress. She said she had only sold seven of her daily paintings so far and two of them were to her dad, so she didn't think those should count.

I was flabbergasted. I said, "Wow, you sold seven already! That's great!" She said, "But I feel like I should be selling *more* by now." After six months? Get real! I didn't start selling my work until *years* after I started painting.

If you want to be good at anything, you've got to put in the time. I've heard it put two ways, and I like them both. You've either got to do five hundred paintings, or put in ten thousand hours before you start doing work you can be really proud of. Either way, that's a lot of brush miles and a whole lot of practice paintings!

If you were going to start learning to play the piano tomorrow, you would expect to put in the same kind of time, right? And you would expect to play a whole bunch of awkward songs, painfully slowly, before you could work your way up to something you would be proud enough to record. But you wouldn't record the practice sessions, right? But as artists, we are essentially recording all of our practice sessions (paintings), and then they sit around our studio, tempting us to sell them or give them away.

If you keep any of your practice paintings, keep them only for documentation of your progress or give them away only because someone *asks*. If you can, wipe the bad ones off and reuse the surface (I do this still, on a regular basis). If your medium dries too fast, make a stack in your studio and throw them out at regular intervals. Personally I don't like painting over old paintings (too much texture and distraction) or returning to ones that didn't work. When paintings don't work, it is usually for some fundamental reason, like the composition was awkward. There is often no easy fix for that, so I choose to simply move on to something I'm excited about now.

If you're serious about art, make sure your five hundred paintings or ten thousand hours are as close together as you can manage. Doing five hundred paintings over the course of three years will give you much better results than doing them over twenty years.

Cietha Wilson, *Playing Monk with Monk*, 6 x 6 in., oil on board, 2013.

Other Lives Changed
by Daily Painting

I have made many friends in the daily painting world and have heard a lot of stories similar to mine. Here are just a few that I find especially inspiring.

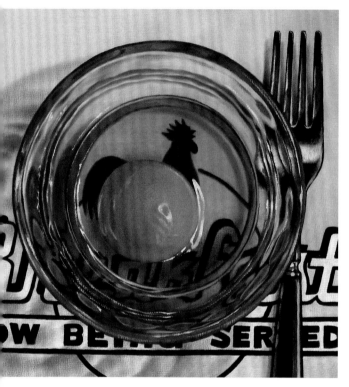

Jelaine Faunce, *Now Being Served*,
6 × 6 in., oil on panel, 2010.

Jelaine Faunce, daily painter

Jelaine Faunce studied fine art at the University of Nevada at Las Vegas and started her career doing giant murals for homes, businesses, and casinos. For her it was "labor intensive and quite joyless," but she learned a lot, particularly that she preferred to paint smaller.

Jelaine first heard about the daily painting movement from a friend who had been through a terrible block and was using the concept of painting small and often to "restore his own sense of joy in creating." Jelaine tried it too and was hooked.

"I had already been selling online, and working in 14-inch or smaller format for about three years when the daily painting movement took off," says Jelaine. "I liked the idea of a 6-inch or smaller format and the challenge of working in a way that would prevent me from weeks of obsessing over a single canvas. It was a freeing, exploratory experience that practically forced me to have fun. In the process, I found new subjects, new ways of arranging my compositions, new ways of looking at my world in general. I went from being a simple observer to being a playful creator. Interestingly, when I did so, buyers became more responsive to my work. I literally became more successful."

Jelaine sells primarily through galleries but continues to sell online as well. She keeps the two worlds separate by sending only larger work to galleries and selling only smaller 6-inch work online. The smaller works are also labeled "studies," as they are usually test subjects for, and never as detailed as, the larger work.

David Morris, daily painter

David Morris attended Leeds College of Art in the United Kingdom, focusing on furniture design and ceramics. After graduating, he spent his career teaching art in a secondary school and then ceramics at Grimsby School of Art. In 1992, David retired early and started doing paintings, mostly in watercolor.

In 2011 David discovered artist Julian Merrow-Smith's website, shiftinglight.com. Julian lives in France and is one of the original daily painters. David followed the links from Julian's site to other artists and soon found the worldwide daily painting movement. Eventually David stumbled onto dailypaintworks.com and joined as a featured artist.

The timing for this couldn't have been more perfect, since the economy was in a recession and galleries weren't selling as well as they had been. David says, "Initial sales after joining Daily Paintworks meant that I had found a way of putting my work before a huge audience. The works had to be fairly small in order to be shipped, but it was an excellent tutor in that I had to consider what paintings would/might be appreciated by a mostly American clientele."

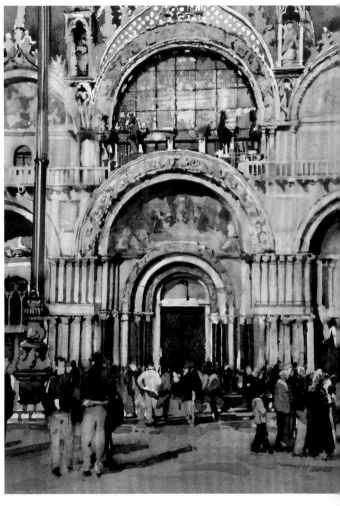

David Morris, *San Marco—Façade*, 12 × 14 in., watercolor on heavy-weight, acid-free paper, 2013.

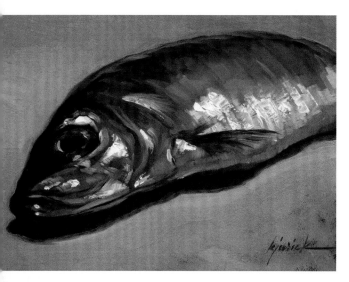

Karin Jurick, *Sammy*, 7 × 5 in., oil on panel, 2013.

Karin Jurick, daily painter

Karin Jurick inherited a frame shop from her parents and ran it for over twenty-one years. But when business started to suffer, she cut back her hours and started painting small, acrylic paintings and selling via eBay auctions, starting at $25. As soon as she made enough to build a studio, she switched to oil.

In 2006 Karin discovered artist Duane Keiser. The title of his blog, *A Painting a Day*, "summed it up for me," says Karin. "I'd been on that same track, completing a painting nearly every day for over four years—and it gave me more ambition to keep working." About seven years into painting, Karin realized "it was possible [to] make a solid living as an artist," so she closed her business and started painting full-time.

"I want to start and complete a painting in a day," says Karin. "I want to move on to something new every morning. I want to paint all different subjects. When I have just a couple of hours in a day, I tend to paint quicker and looser than I do when I've devoted a longer day to painting with a larger piece, and I enjoy that balance of some paintings being more 'illustrative' and some being very painterly. I learn something every single time I paint. It keeps me motivated. It feels like I accomplish something at the end of the day rather than stew over what to do with it the next day."

Karin sells some of her work online and some in galleries. The gallery paintings are "more realized, more time consuming, and a bit larger," while the smaller ones are "quick, looser paintings—apples to oranges, so to speak." Karin says the small studies give her a "better idea of what 'speaks to people,' and that often leads to larger works for the galleries."

Roger Åkesson, daily painter

Roger Åkesson lives in Sweden where he works thirty hours a week helping and motivating people with disabilities, but in his spare time he paints. Before discovering daily painting, Roger was doing only large paintings that took up to one week to finish. He says, "I didn't create, I produced; I didn't try to grow, try new things." Roger also didn't paint very regularly, but that changed in 2010 when he discovered the daily painting movement.

"One gains a lot more experience and learns much more by painting smaller, and invests less in each painting," says Roger. "Spending less time on each painting gives room to experiment, try new ideas, and challenge oneself to simplify."

Another benefit of daily painting for Roger is the huge community of artists who share and inspire each other. He says, done right, "one can get inspired and learn and grow as an individual/artist, without losing one's identity."

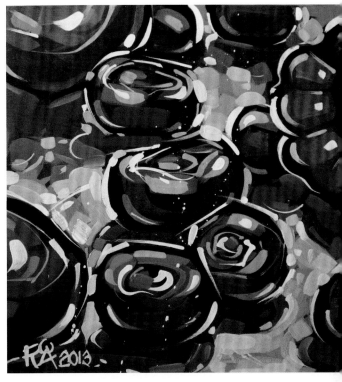

Roger Åkesson, *Blueberry Abstract 14*, 40 × 40 cm. (15.75 × 15.75 in.), acrylic on panel, 2013.

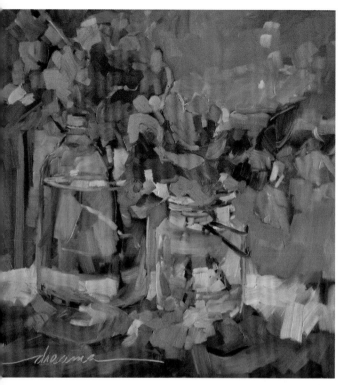

Dreama Tolle Perry, *Color Song*, 12 x 12 in., oil on panel, 2012.

Dreama Tolle Perry, daily painter

Dreama Tolle Perry discovered daily painting at just the right time. For her it "picked up the threads of a runaway life that was filled with too much work and too many days spent watching [her] father slip away."

A self-taught artist who was trying to get her life back, she was "overwhelmed at the mere thought of doing big works (it seemed too serious, too much of a commitment)" and looked at those "small, bite-sized paintings that [she] was seeing pop up online and thought it seemed like . . . a good place to start." That was February 28, 2009.

"Through daily painting, I found me and found my voice," says Dreama. "Small works, done frequently, break down the barrier of fear that surrounds the white canvas. Less fear equals more risk taking. Expressive brushwork and playful color started showing up in my work. I found that I had more JOY in the making of art than I ever had before. Connecting online, getting instant feed-back on a painting that was still wet, gave me what I needed—the courage to follow my heart!"

"Daily painting removed the barriers of waiting for someone else (e.g., a gallerist, a juror, an awards show, or a family member) to "approve" my work before sharing it with the world," Dreama says. "It gave me a chance to believe in myself, which is all any of us ever really need."

2

My Materials

There are too many art materials in the world and too many media to give you any kind of comprehensive review of what's possible to use for daily painting. But I do want to share a few of the materials I have either bought or created . . . okay, that my husband created . . . that have been incredibly useful in painting small and often.

Easels

An easel holds up what you're working on. There are different kinds of them for different needs, but most work for a variety of media. I have two easels. One stays in my studio, and the other I use for plein air painting (that is, painting outside) and for giving demos at workshops. The first is large, sturdy, and versatile. The second is smaller, lightweight, and easy to put up and take down. I use them both primarily for oil, but I could also do acrylic, watercolor, pastel, charcoal, and so on.

For years I had a simple, cheap, metal easel in my studio, inherited from my mother-in-law. If I needed to raise or lower my painting past the constraints of the easel, I used boxes and tape to prop things up, higher or lower. It was far from fancy, and often frustrating, but it worked, and it was free. Honestly, it worked well enough for me for many years, especially when I started doing small paintings.

When I could finally afford a fancier easel, I did a lot of research and settled on one by David Sorg (studioeasel.com) for about $700 (pictured on the next page). He makes two versions, one for 8-foot ceilings and one for taller ones. I have used both, and they are great. I have compared them to other easels and I believe they are absolutely the best bang for the buck.

A sampling of my materials.

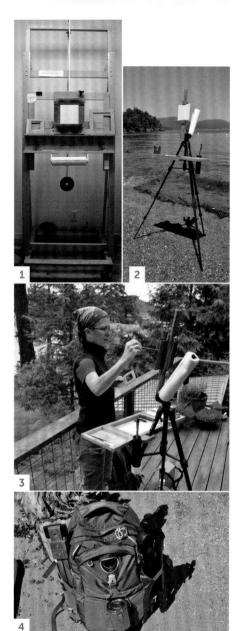

1. My current studio easel, a Sorg Super 8, from studioeasel.com. 2. My Art Box from artboxandpanel.com. 3. Me, plein air painting with my Art Box. 4. My plein air backpack, an Osprey Quantum, packed with all my gear.

They are counterweighted and therefore quite easy to adjust up and down. They grip the edges of your canvas with sandpaper, which makes for a completely solid painting surface. Best of all, they include a handy paper towel holder, which is important to have nearby for any medium.

In front of my easel I have a squishy mat that allows me to stand all day without my feet hurting. Because it's important to back up often to see what I'm painting from a distance, my mat is about 12 feet long and 3 feet wide. I call it my *runway*. I got it from www.uline.com—it's called a Cadillac mat, but any antifatigue mat will do.

For traveling and plein air I have used a pretty fair selection of what's available. I started with a traditional French (Jullian) easel, which was everything a plein air easel *shouldn't* be: big, heavy, awkward, tough to set up/take down, and easy to knock over. Next I was gifted a Guerrilla Box, which was a little better but also heavy and awkward. Then I graduated to an Open Box M (very similar to EASyL), which was nice and small and lightweight but, for my taste, lacked mixing room. For traveling you want something small enough to fit in your luggage, light enough to possibly hike with, easy to set up and take down (because once you find a scene you like, the light is going to change quickly!), stable, ergonomic, and with plenty of room to mix your paint.

For plein air painting and giving demos at workshops, I currently use an Art Box (artboxandpanel.com). This is a very simple system, lightweight, ergonomic, affordable, with tons of mixing room. I use the "mini" version and have installed a piece of glass in the palette section for easy cleanup with a paint scraper. When I travel, I put it in my Osprey (Quantum) daypack. This system is great for oil or acrylic painting.

Panel Holder

When I first started painting on smaller surfaces, I quickly realized I needed something to hold my panels steady that would also allow me to paint off all sides (and bottom) with nothing in the way. After only a little prodding, my wonderful husband invented an incredibly simple device that holds my panels with friction (see image 2, next page).

The top and bottom parts are fixed (glued on) to the back support, and the middle piece slides under the panel and holds everything in place.

The binder clip is insurance that the moveable piece doesn't pop out. All the pieces are the same thickness as most panels—this is very important, in case you're thinking of making your own, because if the pieces were thicker than the panel, there would be a lip at the top and bottom that your paintbrush and paint would get caught in. This holder works best on panels with squared off edges, and mine accommodates only small panels—anything from around 4 by 4 inches to 6 by 8 inches—but larger ones could be made to handle larger panels.

After each painting, I wipe away any paint on the holder (with wet wipes) so it doesn't get into my next painting. After a while you'll get a kind of patina over most of the holder, which makes the wiping easier (and unfortunately also makes it ugly).

The design is quite simple and easy to make (if you are handy or married to a handy person). *Or* you can order it from my friend Karen, whose husband makes them. You will find a link for this on my blog (carolmarine.blogspot.com).

Affordable Taboret

For storing paint and supplies, you can buy a beautiful (expensive) wooden taboret *or* you can visit your nearest home improvement store and get a simple (much less expensive) tool cabinet on wheels. This is what I've been using for years and absolutely love it.

My paint tubes and clean brushes are in the top drawers for easy access. Panels and light bulbs and fabric for still lifes are down below.

My tool cabinet/taboret doubles as a palette. I use a simple pad of palette paper that sits on top. When I fill up one sheet of paper with mixes of oil paint, I use a palette knife to move my big piles to the next page and keep going. Some say the palette should be a mid-value gray. Personally I think you could use just about anything, but what *is* important is to stick with what you're used to. I have tried gray before but my values are always off because I'm so used to white.

There is enough space left over on top of my cabinet to hold anything I'll need while painting. I keep my mineral spirits in a little can with a grate at the bottom, my medium in a little glass jar, and my brushes in anything that will hold them.

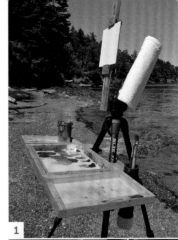

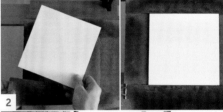

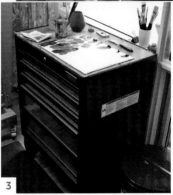

1. A close-up of my Art Box, complete with PVC brush holder (has a lid so the paint doesn't get on anything) also from artboxandpanel.com.
2. The panel holder my husband invented for me (it's ugly because I get paint all over it!), holding a 6 by 6-inch Ampersand Gessobord panel. **3.** My tool cabinet/taboret serves as a palette and a handy place to store painting supplies.

Painting Surfaces

It takes time to find a painting surface that works for you. I recommend trying as many surfaces as you can, experimenting, and not settling until you find one you love. What I use may not work for you, depending on your medium and painting style.

For my oil paintings, I started out with big rolls of canvas that I stretched and primed myself. When I discovered painting small, I would sometimes cut small shapes of canvas (or paper) and tape them to a piece of plywood or foam core. This is definitely a cheap way to go, but if you're looking to sell them I would argue that, for buyers, they aren't as desirable as stretched canvas or panels because they take extra work to frame/hang.

When I started posting my oil paintings to sell, I used Raymar (smooth cotton) panels (raymarart.com). I chose panels because they are affordable, lightweight, easy to ship, and I personally always hated the bounce of stretched canvas.

Several years into daily painting, a friend gave me some Ampersand Gessobords to try. They are basically just hardwood panels that have been gessoed many times. They are slicker than canvas panels, and at first I hated them. I seemed to be removing as much paint with each brush stroke as I was putting on. I was using bristle brushes at the time, and as soon as I tried a softer, synthetic brush with the smoother panels, I was hooked! You can use them with oil, acrylic, or mixed media; brushwork or palette knife. Ampersand also makes other surfaces for other media.

There are plenty of other panel and canvas suppliers that I would recommend trying: New Traditions, SourceTek, and Art Boards, to name a few. I would avoid super cheap ones that say anything about "student grade." The surface you use makes a big difference, so if you're trying to save money, save it elsewhere, like on an easel if you have to. Otherwise you'll spend a lot of time feeling really frustrated.

For other media, I would again recommend trying out as many surfaces as you can before investing in a whole lot of one kind. There are many types of watercolor paper, for instance—many brands, hot press, cold press, and so on. I discovered recently at a pastel workshop that there is a *world* of difference between the Canson paper I put up with in college and sanded paper. While sanded paper is far more expensive, my experience with it was vastly superior, making it worth the expense to me.

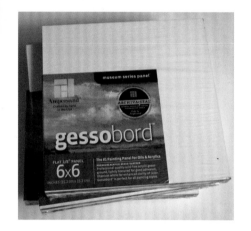

A pile of Amperand Gessobords.

Luckily, we have the Internet at our disposal to research various surfaces (and all supplies!). I recommend reading reviews on different brands and asking your favorite artists what they use.

Wet-Panel Carriers

When you are traveling and painting or taking a workshop, you'll need some way to transport your work. Some plein air easels have a space for wet paintings, but usually just a couple panels. I have several, different-size carriers from Raymar Art that I would highly recommend for oil paintings. They are lightweight, durable, and cute too.

Brushes

The kind of brushes you use helps determine what kind of marks you make. In my experience, filberts and round brushes lend themselves to smoother, more blended marks, while flats and brights are better for marks you are going to put down and leave alone. These last two are what I mostly use.

Most people say bristle brushes are best for oil painting, but I prefer synthetics in most cases, even on canvas. The kind I use are softer, hold a crisper edge, and lay down paint without taking off what you put on before. The downside of synthetics is that they generally have a shorter life span than bristle brushes.

In general, flats are longer than brights, but, depending on the brand, they are all different. You might find a bright you love in one brand that is the same length as a flat in another. Sizes among brands are also different, which can make it frustrating when you're ordering new brushes for the first time. If you have an art store near you, I recommend shopping in person first. Once you find supplies you like, it's generally cheaper to get them online.

My current favorite brushes are Silver Brush Bristlon brights. I use sizes 4 and 6 most often, but for larger paintings, I use 8, 10, and 12. I also have small Silver Brush Bristlon filberts (size 2) for drawing out my subject on my panel before I paint it. I use an old filbert bristle brush (any brand will work) for scrubbing on my ground/wash at the beginning.

One other "brush" I enjoy using has a wooden handle and a rubber tip that comes to a point on the end (pictured on the next page). It is good for making corrections and signing paintings. It will remove paint in a single

1. Wet panel carrier made by Raymar (raymarart.com). **2.** A few of my brushes: a flat Monarch from Winsor & Newton, brights and a Silver Brush filbert from Bristlon Ltd., and short flats from Rosemary & Co.

A few of my rubber brushes: one from Kemper Tools and the other two, Colour Shaper angle chisels, sizes 2 and 6.

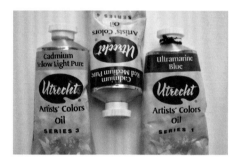

A sampling of my Utrecht oil paint.

area, neatly, much better than a paper towel will. When you sign with it, you are essentially *removing* paint instead of putting more on. I feel I have more control this way (for something so small!) than with a regular brush.

Paint

I buy my oil paint from Utrecht Art Supplies. I get the professional-grade version and have always been happy with the consistency. It is thicker than other paints (less filler), which works for me. The prices are fair, and my understanding is they can sell for less because there is no middleman: they are their own distributor. I have tried other paints but always return to Utrecht. They also make acrylic and watercolor paints, but I haven't tried them.

I use a limited palette (titanium white, cadmium yellow light, cadmium red medium, alizarin crimson, ultramarine blue, phthalo blue, burnt umber, and sometimes cadmium yellow lemon and permanent rose). I feel I can mix just about any color I see with this selection. Some people prefer to buy many colors and mix less. There is no right way; there's just the way that works for you.

No matter what medium or brand you use, I recommend avoiding "hues." They are cheaper versions of the real thing and are tempting to stingy people (I can say that because I am one). They look great straight out of the tube, but you will find you aren't able to mix very bright (saturated) colors, and they tend to be chalky.

This is a small thing, but however you lay out your paint on your palette—try to do it the same way every time. It's one less thing to have to think about.

Medium

Oil and acrylic painters often use a medium (in addition to odorless mineral spirits or water) to moderate the consistency of the paint and either speed up or slow down the drying time. I personally use medium for two reasons: to thin the paint and therefore extend each paint mixture/stroke *and* because when I'm done and my oil paintings are dry, the medium leaves a kind of sheen over the whole surface (if I add it evenly to my paint) that allows me to skip the varnish.

There are plenty of commercial mediums to choose from for oil painting, but personally, I've never been crazy about any of them. The one useful thing I learned in college was this recipe:

> one part stand oil : two parts linseed oil : one part OMS (odorless mineral spirits)

You don't have to be exact with the amounts. Stand oil is quite a bit thicker than linseed (it's actually just a thickened linseed oil—about the consistency of molasses), so if you feel your mix needs to be thicker, just add more of that. If your mix gets too oily, add more OMS—you'll need to do this anyway as the OMS evaporates slowly over time if you leave it uncovered. I cover mine when I'm not using it and find I have to add OMS once a month or so.

Whatever medium you choose, it's important to get a feel for how much to add to your paint. If you use too much, your paint becomes too thin. Every time I mix a little pile of oil paint and I'm about to put down a stroke, I stick the corner of my brush into my medium until it just breaks the surface, mix that into my pile, and then paint.

Washing Brushes

For years I used Old Masters Brush Cleaner on my brushes until a student recommended Murphy Oil Soap. This is something you can get cheaply at the grocery store (for cleaning wood floors). Not only does it clean faster, but it leaves brushes soft and conditioned.

Additionally, if you forget to wash your brushes one night (as I do on a regular basis) and you come back the next day to rock-hard bristles, just fill a jar partly full with Murphy's, put your brushes in, bristles down (don't soak the metal parts [ferrules]), let them sit for twenty-four hours, and clean as usual. All the paint comes out. This works for oil and acrylic, and it's good for getting paint out of clothes too!

Years ago when I was looking for ways to be safer with my paints, my husband had the brilliant idea of cutting a tennis ball in half and using the inside of it, rather than my hand, as a place to rub the soap and bristles. The rubber gently massages the bristles and gets them clean quickly, without damaging them.

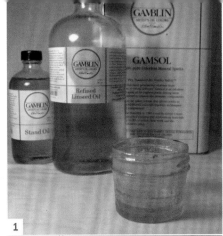

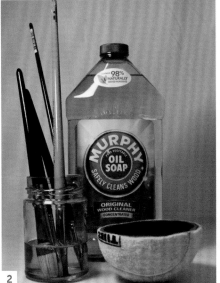

1. The ingredients for my oil painting medium—stand oil, linseed oil, and Gamsol (OMS). **2.** For cleaning brushes I use Murphy Oil Soap and a tennis ball cut in half. If paint has dried on my brush bristles, I leave them in a jar of straight soap for twenty-four hours. Magic!

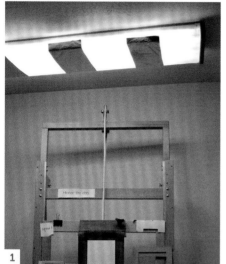

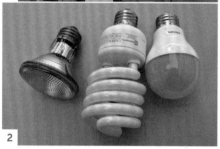

1. Because I paint too dark when I have too much light, I cover part of my fluorescent light fixture with foil—not pretty, but it works. **2.** The bulbs I like to use to light my still lifes: a Sylvania flood, an EcoSmart fluorescent, and a Philips LED.

Lighting

Studio

My studio is in western Oregon, so I can't count on natural light by which to paint (too rainy). Even in Texas, I lived in a forest so trees blocked a lot of my light. For years I've been supplementing my north windows with fluorescent light. I have a large overhead fixture hung directly over my easel (so I don't get shadows or glare). I buy daylight balanced bulbs, and the most expensive fixture I can find (so my lights don't buzz or flicker).

I find if I have *too* much light, I unconsciously compensate by painting darker. For that reason I have in the past reduced the number of bulbs in my overhead fixture (that holds four) down to one. Lately I have been experimenting with using two bulbs (one warm and one cool) and covering part of my fixture with foil to cut down on the amount of light. It's not pretty, but it works. If you don't find you have this problem, use all the light you want.

Still Life

When lighting still life objects, you have many choices, including natural light. Some say north light is best, but I think it depends on what kind of mood you're trying to create. I encourage you to try lots of different lights until you find one or some you like. I have three that I use on a regular basis:

- Sylvania 39W, 2800K flood
- EcoSmart 27W, 5000K spiral fluorescent
- Philips 60W, 3000K LED, bright white

The flood light is hot and creates strong, sharp shadows and a dramatic feel. It's also the yellowest of the three. This is the light I use most of the time. FYI: If you get one with too much wattage, it tends to cook your still life subjects.

The fluorescent light is softer and better for delicate subjects like flowers. It is also the "whitest" of the three, and leans a little toward blue.

The LED light isn't as focused as the flood, which softens the shadows and gives a less dramatic feel. This bulb doesn't break if you drop it (a definite plus for me for traveling to workshops) and it doesn't get hot, which is also good for painting anything that wilts.

Often I use the flood pointed directly at my subject, and the fluorescent pointing into the corner of my shadowbox, along with a (blue) North Light filter, to create a cool, indirect light on my subject. I buy my filters from the blog of artist Qiang Huang (http://qiang-huang.blogspot.com; look for "North Light Filter"). The effect from this is interesting to me in that it makes the shadows cooler—more blue.

Shadowbox

When I first started doing still life, I used a complicated series of stacked boxes to prop up my subjects. I quickly found it to be time-consuming, frustrating, and rather unstable, causing *me* to be unstable as well, so I asked my husband for ideas. I wanted something lightweight, that was easy to raise and lower and would also block the light from my overhead bulbs.

What followed were several prototypes ending in the shadowbox I use today. It is constructed of PVC and plywood, and the whole thing is mounted on a sturdy tripod that goes up and down with a hand crank so I can get every view from eye-level to bird's-eye. I drape cloths over my box to block the overhead light—first white and then black. The white cloth allows the light inside the box to bounce around, while the black does a better job at blocking the light from overhead. I have a lamp with a long, adjustable gooseneck that I attach to the PVC and aim wherever I need it. My second lamp is a cheapie that I use to point up into the corner of my box.

If you are interested in a shadowbox but don't have someone handy around to build one for you, on my blog (carolmarine.blogspot.com), you'll find a link to a couple who is selling them premade. They call it a Still Life Stage, and it's almost exactly the same as mine (minus the tripod)— maybe a little better.

Miscellaneous Supplies

Paper towels are a must for most media. I've tried a lot of them, and Bounty ExtraSoft is my current favorite. Many others break apart easily or pill up.

I also keep a container of wet wipes handy at all times. I use them mostly to keep paint off my skin and also to wipe off my panel holder between paintings. I prefer the Costco brand, scent-free baby wipes.

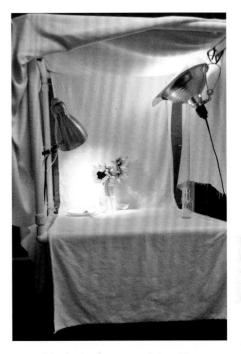

My shadowbox, complete with sunflower still life. For this setup I have the flood bulb pointed at my subject and a small fluorescent light, covered with a (blue) North Light filter, pointing up into the corner of my box.

Flying with Paint

Unfortunately they don't allow us to carry OMS (or anything flammable) onto airplanes. So you must find those things when you get where you're going, ship them there ahead of time, or borrow them. This is terribly inconvenient, but alas, it is a burden we must bear as traveling artists.

I pack all my paint tubes in my checked bag, carrying them in a leak-proof Tupperware container or a Ziploc bag. The bag takes up less room but isn't as pretty. I include a Material Safety Data Sheet (MSDS) too. You can find an MSDS on the website(s) of your paint manufacturer(s). Basically, it lets everyone know that your paint won't explode in the belly of the plane. This soothes the nerves of the TSA people.

I have a nifty brush holder made of PVC pipe (from artboxandpanel.com). Once I accidentally left it strapped to the outside of my carry-on backpack. This big TSA guy tapped me on the shoulder and said, "Ma'am, what is this?" I said, "Oh shoot, am I not allowed to bring paintbrushes on the plane?" He said, "It's not that . . . it's just that it . . . it's just . . . ma'am, do you know what this looks like?" Apparently it looked like something I wasn't supposed to bring on the plane (a pipe bomb?), but he let me on anyway. Nice guy.

I carry my traveling easel, with glass in it, inside my backpack along with my laptop. This is one of my carry-ons, which means it never leaves my sight and I can make sure it doesn't get banged around. I also keep my LED light bulb in my backpack. Sometimes the TSA folks run this through twice, but they always let me go.

Square Dance, 6 × 6 in., oil on panel, 2008.

Subject Matters

Daily painters paint lots of things, in lots of ways, with lots of materials. There's no way I can cover them all, but I do want to give you an idea of what's possible by showing you an assortment. I've also asked some of my favorite daily painters to give some tips on how they do what they do. Below, I've divided subjects into six main categories. Obviously this isn't a totally comprehensive list—your choice of subject matter is limited only by your imagination! But these categories appear most regularly on dailypaintworks.com and seem quite popular among painters and consumers both.

1. Still lifes and flowers

2. Landscapes (includes sea- and skyscapes)

3. Animals

4. People (includes figurative subjects, portraits, children, and sports)

5. Cars and buildings (includes interiors and cityscapes)

6. Abstracts

Here are some of the materials people use:

- Oil
- Acrylic
- Watercolor
- Pastel
- Mixed media
- Pen and ink
- Graphite
- Gouache
- Printmaking
- Colored pencil
- Charcoal
- Scratchboard
- Fiber art

Again, this is not a complete list, but hopefully it gives you an idea of what is possible. I have a friend who does a mosaic a day and another who throws a ceramic pot a day. Making art daily seems to work regardless of the medium you choose.

Still Lifes and Flowers

Still life is a popular subject and my personal favorite. I love it because I am in full control. I can set up my subjects any way I want, with any background; light it from any angle, with any bulb; paint it from life, take a photo first, and so on. I also love the bright colors of fruit and flowers and fabric and all their various combinations.

Victor Tristante is a daily painter living in Spain who paints a variety of subjects, including some particularly beautiful still lifes. He says he loves that you can create "another world just by mixing ordinary objects in different arrangements. You can tell infinite stories in a reduced space." Victor is intrigued by the idea of trompe l'oeil—that you can create the *illusion* of space with a painting. "I try to compose the objects to emphasize this concept of weight and three-dimensionality," he says. Victor paints from both life and photos but says the advantage of photos is he can take one hundred of them for every still life. And with a photograph, you don't have to worry about your subjects wilting or discoloring or otherwise losing elements of the composition that you love. "I must move things around a lot before the composition likes me. And also, my cats tend to eat my setup if I leave it there for too long," says Victor.

Many people think of still life as a beginner subject, and I agree it is good for those people just jumping into painting or drawing. The advantages of still life are huge. Most of them don't change much over time. There is no sun going across the sky or shifting shadows as you get with landscape, and unless you're painting flowers, your subject isn't going to move like your dog will if you try to paint him.

Another advantage of still life is that precision and proportion aren't as critical. If you paint your aunt Linda, she may have a problem with how big you painted her nose, but an apple will never complain. And your viewers will never know you made the pear too fat or the vase too tall.

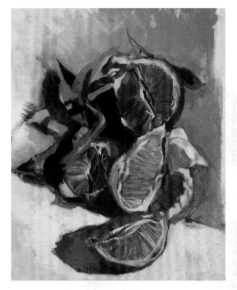

Victor Tristante, *Piled up Fruits*, 9.4 × 7.4 in., oil on panel, 2012.

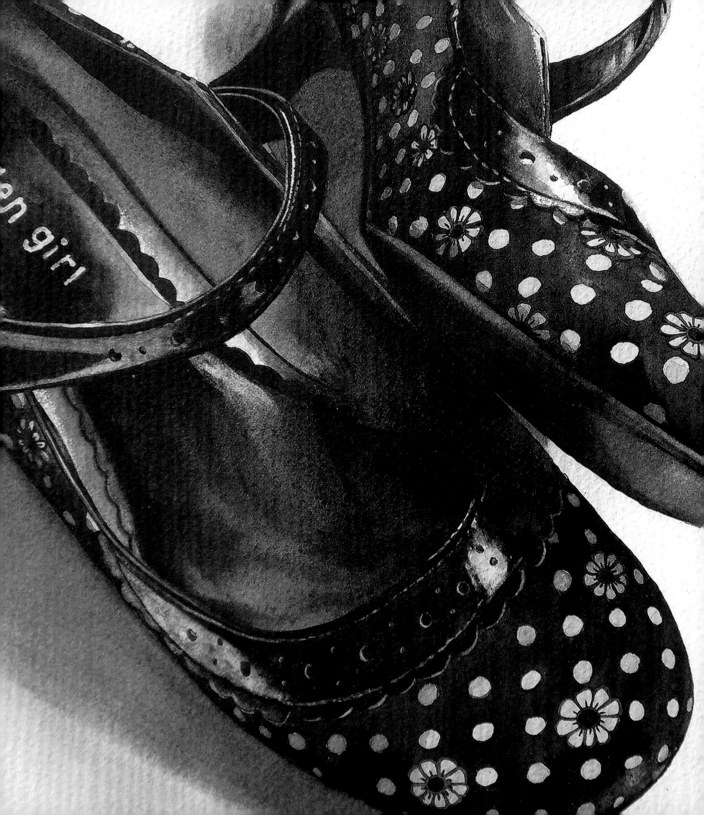

You can also paint in the comfort of your own home. If you're new to painting, the idea of dragging your gear out into the world for all to see can be incredibly daunting for many reasons. Even if you're a seasoned painter, weather can sometimes prevent you from venturing out, and on those days, it can be a nice change to give still life a go.

Julie Ford Oliver loves the still life because she can "find shapes and colors and have them talk to each other." She says, "It most likely is a personal-taste issue, but still life is the only thing that allows total control of what is in front of me. Once I have painted the objects, they are firmly in my mind and I find more and more I can paint them from my imagination—creating more than my setup." Julie creates full, beautiful paintings with oil, acrylic, watercolor, and other media. She likes to work from life because she finds photos can't "capture 'volume' very well and the shadows can be quite awful," she says.

Raymond Logan is another wonderful still life artist. He likes still lifes for the same reason I do—because he is in control. He says, "The long-suffering items are there, right in front of me, at my mercy or beck-and-call, to be arranged and lit in the manner I desire." Raymond says specifically, "Still lifes containing food are fun to paint because I get to eat the subject(s) when I am done. That is probably why I do not paint baked goods—they never last long enough for me to be able to complete a painting." When I asked him if he prefers painting from life or photos he said, "I prefer painting from life. If I spend enough time getting the setup right, the lighting just the way I want it, getting the exposure right, etc., etc., etc., and then snap a shot, the photograph itself is a piece of art. Why paint a piece of art from a piece of art that I already labored so hard to achieve?"

Kara Bigda used to play a game with her family when she was growing up, where one person would draw something from around the room and the others would guess what it was. She's not sure if that was the key to her love of still life, but it certainly made an impression. Kara paints stunning watercolors of a variety of subjects, including people, animals, and buildings, but her primary inspiration is still life. She paints fruit, cupcakes, toys, shoes (as in *Madden Girls*, opposite), bottles, flowers, and so on.

Julie Ford Oliver, *Marigolds and Zinnias*, 6 × 8 in., oil on canvas, 2012.

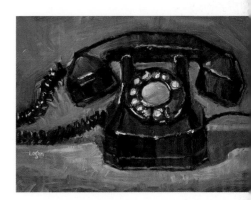

Raymond Logan, *Old Automatic Electric Telephone*, 4 × 6 in., oil on panel, 2013.

Kara K. Bigda, *Madden Girls*, 8 × 8 in., watercolor on paper, 2012.

Kara says she prefers still life because "depicting three-dimensional objects on a flat two-dimensional surface is difficult enough without having to contend with the changing light of, say, plein air painting. I'm a detail person also, and until recently have always been completely overwhelmed by the detail in nature. I just couldn't *chunk* the details of, say, a tree into shapes. I'd obsess over each leaf (crazy!) and ultimately get bored and frustrated."

You might not think of flowers as a still life subject unless they're in a vase, but they have been a very popular subject for daily painters, and I couldn't think of where else to put them. A single rose or other flower on a single, small canvas is a perfect fit. When I paint flowers like this, I mostly do them from photos. In the spring and summer I take trips to my local public rose garden and snap hundreds of photos at a time of roses that I can paint *all* year, from angles I would *never* have gotten had I painted from life.

Jacqueline Gnott is a daily painter who often paints single flowers. She is a watercolor artist whose paintings are simply stunning. She says, "I love flowers because of their unique individuality. Each one is different yet so very special in its own way. I love roses for their delicate simplicity, irises for their complex veining and inner depth, peonies for their abundance of petals." Jacqueline prefers to paint from photos. She says her goal is to "capture that one perfect moment of light," and that her style of realistic painting requires a fair amount of time, making it difficult to paint them from life. "Using my own photography allows me to paint anytime, for any *length* of time," she says.

Some people will tell you you're not a *real* artist if you paint from photos, but in my (and many others') opinion, that simply isn't true. I can name *many* fantastic artists who paint *only* from photos. It is important to know the limitations of the camera versus the human eye, but it is also important to consider the limitations and frustrations of painting from life. Here are a few benefits of painting the still life from a photo:

- You can get angles with the camera that you may not be able to get by standing in front of something and painting it (for example, a close-up of that perfect rose in the middle of the thorny bush).

- You can paint with a smaller setup if you've only got a photo to look at (no shadowbox needed).

Jacqueline Gnott, *Peach Iris*, 8 × 8 in., watercolor on paper, 2013.

Halved and Halved Again,
6 × 6 in., oil on panel, 2012.

Exercise—
Explore Still Life

Wander around your house and look for one or more simple objects to paint. Avoid heavy patterns or textures. Consider subjects like fruit (whole or cut up), vegetables, simple one-color cup or mug, plate, silverware, vase, flower, toaster, and so on. Now find a simple one-color background (paper or fabric) and set up a still life. Try lighting it with different lights from different angles. Try putting it on a low table or high one. Look at and crop your scene with a viewfinder (more about this in chapter 6). Give yourself plenty of time and don't stop until you find a scene you're excited about. Then paint it with your chosen medium. Have fun!

- If your setup is lit with natural light, you capture the moment rather than having the light and weather change throughout the day.

- You capture subtle/fine details that may change depending on *exactly* where you're standing to look at a still life (for example, distortions through glass).

- You don't have to race to paint objects that move or change quickly, like some flowers and produce (radishes, for example).

I like to take a photo as a backup for some still life subjects and then paint as much from life as I can. I know my camera cannot capture the huge variety of values and colors I see with my eye, so when I can, I prefer to paint from life. I find this strategy combines the best of both worlds.

If you're interested in still life but aren't sure where to find your subjects, here are a few ideas to get you started:

- First look around your house and kitchen for props you might have taken for granted.

- Visit your local grocery store or farmers' market for produce, flowers, jars of interesting looking things, candies, and so on.

- Browse thrift stores for plates, cups, vases, shoes, old cloth napkins, and pillow cases for backgrounds, and so on.

- Peruse junk shops and antiques stores.

- Visit fabric or craft stores for fabric and paper to use for backgrounds.

- Hike around the great outdoors for flowers, leaves, rocks, found objects, and so on.

- Ransack friends' houses for their knickknacks.

Landscapes

In my experience, there are two majorly different ways to approach the landscape. One is to get out in it and paint, "plein air," from life, and the other is to paint from photos. I find that the former—painting from life—is *absolutely* the best way to capture a landscape. Admittedly, "plein air" sometimes involves a sunburn and bug bites and your scene changing dramatically as the sun darts across the sky and clouds come and go. While this can be a thoroughly frustrating experience, especially if you don't have the right supplies, it can be highly addictive and satisfying once you get the hang of it.

One daily painter who recommends painting from life is **Barbara Jaenicke.** She says, "Nothing beats learning to see the landscape when you're standing in it, so I do as much plein air work as possible." By painting outside and often, Barbara has become an expert at rendering light sensitively. Even though *Fresh Air and Sunshine* (at right) was created from a photo, it is clear that she has applied the lessons she learned from spending tons of time outside. "By painting outside on a regular basis," Barbara says, "I'm accustomed to knowing how light and shadow actually fall on the landscape, versus the inaccuracies that the camera captures. When working from my photos, I often will adjust the shadow areas in Photoshop to appear more like how I know they would look if I was standing right there in the landscape."

The other way to approach a landscape is to paint from photos. **Robin Weiss** does some of both (from life and photos) with fabulous results. He says, however, "I work increasingly more from life as I discover why many plein air painters stay away from photos. The camera just cannot record what the eye and the other senses can pick up from being present at the scene. But to be clear, artists should feel no guilt whatsoever about working from photos to get a successful painting. I just think they will [be more successful with] the photo the more they paint from life." Sometimes circumstances—weather, time, and passersby—prohibit you from painting landscapes from life. In these instances, painting from a photo is a perfectly acceptable alternative.

Painting from photos can be far more comfortable than from life, but it is very important to understand the limitations of a camera versus the human eye, as mentioned in the last section. To help you visualize this, imagine that the range of values you can see with your eye is represented by a yardstick. Now imagine chopping off the first and last foot or so. What you're left with are the values a camera is able to capture. Not much left, right? You've probably noticed when taking photographs that the shadows

Barbara Jaenicke, *Fresh Air and Sunshine*, 8 × 10 in., pastel on mounted archival paper, 2013.

Robin Weiss, *Snoqualmie Ski Run*, 8 × 8 in., oil on panel, 2013.

tend to turn black, or at least very dark, and the sky (or anything outside a window) turns white. These are the ends being "cut off"—the dark and light values.

You may also have noticed, after a vacation at a stunning place, that your photos of it aren't nearly as stunning. This is because the colors we see with our eyes are more varied and vibrant than what the camera is able to capture. The colors in the photos can also vary depending on your camera settings. For example, when you use the AUTO setting, your camera pretends you are taking a picture on a sunny day, even if you aren't, which can shift all the colors in the resulting photo. (For truer colors I use a P (program) setting, which unfortunately, not all cameras have.)

The Wahine (at left), by **Randall Cogburn,** is a great example of a landscape that focuses primarily on water. Randall paints from life whenever he can, and since he has a particular fascination with the ocean but doesn't live near it, he must rely on photos somewhat. He says, "Painting plein air is the toughest way to paint; however, it can be very rewarding when you get a good one. You'll know it, because your scene has captured the light as it has lit up the clouds, sky, water, and land in a way that [these elements] complement each other." Randall says if he's learned one thing from so much painting it is to "observe, mix paint, apply with one stroke, and repeat."

If you are new to landscape painting and wondering where to go to paint en plein air or to photograph lovely scenes to paint later in your studio, here are a few ideas to get you started:

- Visit parks (big or small; local, state, or national) for all kinds of varied scenery.

- Drive through the countryside to find lots of open sky and clouds (skyscapes), fields, barns, creeks, rivers, distant mountains, country roads, and so on.

- Head to the beach for water (seascapes), dunes, cliffs, caves, and so on.

- Join a local plein air group for regular meetups at tried-and-true locations, potential access to private property, support and camaraderie, and the occasional field trip to greener pastures.

Randall Cogburn, *The Wahine,* 8 × 8 in., oil on panel, 2013.

Dean Shelton, *Cloud Study 2,* 4.5 × 7 in., watercolor on paper, 2013.

Nadi Spencer, *Willow*, 16 × 8 in.,
acrylic on canvas, 2013.

Rita Kirkman, *Bun*, 6 × 6 in.,
pastel on gatorboard, 2013.

Animals

As you can probably imagine, animals are particularly hard to paint or draw from life, but I have seen it done. I also know a few people who can draw a perfect horse from memory! But if you're anything like me (a *regular* human), you'd rather rely on a photo.

Taking a photo of an animal, a paint-worthy photo, is no easy task either. Animals are usually too shy, frisky, and needy of attention to sit still, too curious, or just plain won't stay where you want them.

I have found, in general, that *time* is the answer. I have gotten my best pictures of animals by hanging out with them for long periods of time and waiting for them to do something cute. Then the trick is to catch them with your camera before they move!

Nadi Spencer creates really fun paintings of dogs, among other things. Her advice for taking good photos is, "Don't have expectations! Start shooting, use a clicker and funny mouth noises and shoot like crazy." Nadi paints dogs from all over the world, so she often has to work from other people's photos. Her clients provide her with tons of options, and she picks what she wants, often combining two or more photos. She says, "They don't know what I'm looking for in a photo, so letting me choose gives them the best portrait." Nadi has been a dog fanatic since she was four years old. "Looking at a beautiful animal, connecting to them through the eyes, sharing that joy—those are the things I try to convey with my brush," says Nadi.

Rita Kirkman is another painter of animals who works from photos. Whether she is using oil or pastel, Rita consistently creates beautiful paintings with rich color and dramatic light, like *Bun* (at left). She says she prefers to take photos of ranch animals "on a sunny day, and ideally, where the sun is at an angle in the sky and slightly behind the animals." That's where the drama comes from. She advises, when you want to take pictures of animals that "move a lot (like bunnies or ducks), a good camera with a rapid-shot mode that can take several shots per second is extremely helpful! Just hold that button down, man! It's almost like taking slow video!" Rita also recommends "a view screen that flips out. Small animals can be shot from their own viewpoint by holding the camera down by your knees; that saves your back and legs from bending or crouching, and you still have full use of your legs for chasing them when they run."

Diane Hoeptner, *Dragon Cat*, 10 × 10 in., oil on wood, 2012.

If you haven't seen **Diane Hoeptner's** cat paintings, you're in for a treat. She manages to capture the soft, velvety feel of fur, and often puts tapestries in the background that balance perfectly with the attitudes of the cats. Diane says getting good photos can be difficult because, "left to their own devices, my cats prefer to lounge and stare into space. Getting them to look up, reach, and play can be a challenge! I recommend shooting from ground level, head on, or even above to capture interesting silhouettes. Use natural light, and take many more pictures than you anticipate needing." She also recommends using the *macro* setting on your camera for close-ups, and disabling the flash for more natural light.

Diane says she discovered a new level of creativity with her cat paintings. "The desire to capture their (alternately) regal and snarky behavior in a way that wasn't cliché or *cute overload* became a passion," she says. "This in turn opened me up to new ways of seeing and painting in general."

Catherine Harley works in different media, from oil to pastel to charcoal to acrylic to gouache, to create a variety of dynamic animal portraits. She says her goal is to catch the "emotions, personality, and attitudes in them." Catherine takes lots of photos to make sure one has "the perfect expression for the painting," she says. "I also love taking photos of food market stands and especially fish stalls! It is much easier to take good photos as my model is not moving (the only risk I take is to look crazy taking pictures of dead fish)!" Christine says painting fish this way "is almost like doing an abstract painting, and the subject becomes secondary. I can concentrate on the composition, textures, and colors."

If you are interested in painting animals but have none of your own, here are a few ideas to get you started:

- Borrow your friends' animals, or visit dog parks and ask the owners if you can take pictures of their dogs.

- Visit zoos and petting zoos—they're not just for kids!

- Attend livestock auctions—get there early for some lovely close-up photos of cows, goats, sheep, and so on, before the sales begin.

- Put up flyers at feed stores asking if anyone with animals will let you visit their farm/ranch to take pictures (include images of your work in the flyer).

- Announce on your blog or website that you want to paint pets and ask that anyone interested please send you photos. You can offer to give them the painting if they will recommend you to others.

Catherine Harley, *Fresh Fish 1*, 9.8 × 9.8 in., oil on panel, 2013.

People

People are quite possibly the most difficult subjects to paint, especially if you are shooting for likenesses. Many daily painters do scenes with people in them, but often the people don't need to be recognizable. They are just characters in a greater scene. I am one of these people-scene painters, and I prefer to use photo references for this type of painting.

It can be tricky taking pictures of people out in public. They are often suspicious. But if we went around asking permission, it would take too long *and* we would lose the spontaneity of the poses. So I have come up with a few ways to be more covert, and therefore, hopefully, less offensive:

- I dress down so as not to bring extra attention to myself (wearing black or muted colors and no flashy jewelry or accessories).
- I use the flip-out LCD panel on my camera so I can hold my camera low while taking pictures.
- I use my zoom lens, or I zoom in later while editing.
- I have a friend pose near my subject.
- I take pictures all around, including behind, my real subject.

Kathy Weber, *Waiters Waiting*, 8 × 10 in., oil on panel, 2013.

Kathy Weber is a painter of people scenes. She carries a small digital camera in her pocketbook at all times, along with a spare, charged battery. Her camera has a little red laser light that comes on right before she takes a picture, but because that makes her more conspicuous, she has placed a small piece of opaque tape over it. Kathy painted *Waiters Waiting* (at right), which is one of my personal favorites of her work.

There are all sorts of places to find interesting people scenes to photograph. Here are a few of my favorites:

- Outdoor markets or fairs
- Downtown areas
- Beaches
- Airports, train and bus stations (or on trains and buses)
- Anywhere tourists hang out
- Coffee shops or restaurants
- Hotel lobbies
- Museums or galleries

Belinda Del Pesco avoids the trouble of photographing strangers by always painting people she knows. She raids her family's photo albums for old and new pictures of family and friends. "I find the familiarity of facial features, gestures, expressions, and carriage incredibly fun to paint, draw, and carve, because I'm usually thinking about that person or the event where the photo was snapped as I work," she says. "It's like spending time with them in my studio. Every once in a while, I'll doodle a made-up face or figure, but I can usually pick out features from my friends and family that snuck into the art because those shapes are steeped into the familiar muscle memory of my art-making."

Belinda prefers painting from photos, "mostly because it's familiar, and painting from life is a different animal altogether. My friends and family are too busy to sit for hours and days while I work on a painting." When I asked her if she had any advice for aspiring artists, she recommends painting friends and/or family if you've never done it. "Since you're intimately acquainted with those eyes, that smile, the tip at the end of this nose, you're doing less familiarizing and analysis, and more of an innate capture," she says. "The *know* part is already done, so you can put that away, and focus on the *see* part of the directive: *Paint what you see, not what you know.*"

Portraits are another type of people painting. Here getting a likeness is crucial. If the eyes are slightly too close together or the mouth is a little wide, the likeness is compromised. If you are working from life, I recommend measuring with your brush and fingers (more about this in chapter 6) to get proportions right. If you are working from a photo, you might consider gridding both the photo and your painting surface proportionally. Or you could use a projector to project the photographed image on your painting surface and draw the person that way first. *Neither* of these methods is cheating, no matter what anyone says!

Felicia Marshall paints really fun paintings of people—mostly children and largely from photos. "I love photography," says Felicia. "Painting is a treat for me. I usually don't have the luxury of time, so I have to paint whenever I can. Working from photos works great for this reason." When I asked Felicia what intrigues her most about painting people she said, "Every single one of us has a story. Most of us don't think it's worth telling. I love

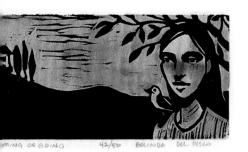

Belinda Del Pesco, *Coming or Going*, 2 × 4 in., linocut and watercolor, 2013.

Felicia Marshall, *Glasses What Glasses*, 8 × 10 in., acrylic on board, 2013.

capturing moments that we don't recognize as unique or special but that we all recognize as familiar."

If you want to work from life, but no one you know will sit for you, look for a local figure session to attend. These are often held at universities or art centers. A lot of daily painters do this and sell figure paintings and drawings. *Black & White #24* (at left) is a lovely example by **Michael Mikolon,** done with ink. Michael hosts weekly figure sessions in his studio and says, "Figure drawing practice is like going to the gym; working that drawing muscle sharpens my skills. The biggest thing I get from doing so many nudes in one word is, *gesture*. This crosses over into all of my work—drawing is the biggest key to painting."

Cars and Buildings

Old cars, trucks, and tractors are some of my favorite subjects to paint, and a lot of daily painters seem to share this fondness. I have found a few places around the United States packed with these subjects (like the Gold King Mine in Jerome, Arizona) and a few parked in various spots around towns and cities, but many that I see from the road are on private property. A word of wisdom: If you plan to approach folks about painting their cars—phrase it properly, and if possible, bring an example of your work so they can see what you're talking about. "Can I paint your car?" will just lead to confusion.

Michael Naples is a daily painter who mostly paints still life but will occasionally knock out a stellar old car (see his work on the next page). He finds his subjects by driving around his hometown and tries to snap pictures as the sun is setting for some really nice lighting and atmosphere. Michael paints from photos mainly because "I'm at a phase in my life when the soonest I have a chance to paint is late at night and the sun is long gone," he says. Michael is attracted to the body lines, details, shiny paint, and chrome, but for him it's "not about the specific make or model of the vehicle; it's more about the lighting and composition of the painting," he says.

Buildings and houses are also popular daily painting subjects. I like to spend hours or days at a time roaming around towns and cities, or driving

Michael Mikolon, *Black & White #24*, 12.5 × 9.5 in., ink on card stock, 2013.

All About Me, 6 × 6 in., oil on panel, 2011.

Exercise—Self-Portrait

There are two ways to do this exercise—from life or from a photo. (1) Use a mirror and set it up so you can see yourself and your painting surface. This is arguably the more difficult of the two—it's tough to keep an interesting expression going for an entire painting. (2) Take some pictures of yourself or have someone else take them. I find if I take them myself, I can explore more interesting expressions—simply turn the camera around and start shooting. Take lots, and paint or draw your favorite.

through the countryside, looking for cool scenes to paint. I have a few rules of thumb for these outings:

- Be open to anything that catches my eye—look with an open mind.

- Squint at scenes to see if the values are interesting.

- Be prepared to take lots and lots of pictures for only a few usable ones.

- Keep hydrated and fed—a grumpy artist makes for a lousy outing.

I am also including cityscapes in this category because, really, they are just collections of buildings or scenes among buildings. A day spent roaming around a city is a day of bliss for me, and I use the same rules as listed above. You can find good pictures any time of the day, but I find the dramatic light of morning and late afternoon very exciting! Here's an example of a cityscape I did from a photo I took in the morning in San Francisco, called *Shadowy Corner* (at right).

One quick trick I would like to share about painting from photos is a tool that lets you "see" into dark shadows in your photos. Basically this tool targets these dark areas and lightens them without lightening anything else in the photo. I use Adobe Photoshop for this, but there are similar tools in other photo-editing programs. The one in Photoshop is called Shadows/Highlights and can be found under Image > Adjustments. With an image open, simply choose the Shadows/Highlights tool, and a little window will open with two little sliders (one for shadows and the other for highlights). The example images at right show one that is straight from my camera and one that has been lightened with the shadows slider (I pulled the little triangle slider to the right to lighten the shadows, but I didn't adjust the highlights slider). I use this tool for almost all of my outdoor photos from which I am going to paint. If I adjust it too much, I lose a lot of the contrast so I am careful with that.

Christine Bayle is another cityscape painter, but she prefers to paint from life. Her goal, she says, is to "understand how light works." And she feels plein air is "the best studio for studying light." She doesn't like working from photos unless she's spent time sketching at her location first and has taken her own photos. When choosing a place to paint, Christine listens to her inner voice when it says "Here, now!" This includes "a place to stand, not too much external disturbance, enough time for the subject, [and so

Michael Naples, *Ol' Blue*, 12 ×12 in., oil on board, 2010.

1. Photo reference for *Shadowy Corner*, taken in San Francisco, 2013. **2.** *Shadowy Corner*, 6 × 6 in., oil on panel, 2013.

3. Photo of windows in San Francisco—straight from my camera. **4.** Same photo, modified with Shadows/ Highlights tool in Photoshop.

Christine Bayle, *Radicondoli*,
6 × 8 in., water-mixable oil
on canvas paper, 2013.

Jo MacKenzie, *Refrigerator 2*,
7 × 10 in., watercolor on paper, 2013.

on]. . . ." The most important thing, she says, "is to get the moment right, not the result." Christine created *Radicondoli* (at left), a simply delightful sketch, when she was in Tuscany.

Many daily painters also paint interiors. Popular are intimate scenes of houses or private areas, or more public interiors of museums, galleries, train stations, restaurants, coffee shops, and so on. Or you can go one step further and paint the interior of some*thing*, like a fridge, as **Jo MacKenzie** did in her gorgeous little watercolor painting, *Refrigerator 2* (below left). Jo paints a wide variety of subjects and says she loves a challenge: "The more impossible a subject seems, the happier I am to try it because if I fail . . . I never thought I could do it anyway and if I succeed, I am happier than I could ever imagine." Jo also says, "It doesn't matter if you never painted a refrigerator before. . . . [E]verything is just shape, value, color. . . . Get those right, and a painting appears and that is what I live for, that voilà moment of *reveal*."

I have painted a few interior scenes from life, but mostly I take photos of cool places I go and then paint them later. I always try to remember that my photo is giving me only a limited amount of the information I saw in real life. Therefore I feel free, as I always do when working from photos, to take some artistic liberties. I may leave out awkward lines, change the local color of one or more objects, simplify or suggest a group of people, and so on. The photo serves me—I do not serve the photo.

Erin Dertner splits her time between plein air and painting from photographs. She's modified her technique a bit when painting from photos: "Because I have spent countless hours on location, I now know how to enhance my paintings that are created while using photos. I know that the shadow areas are not black, for example, but many different colors and values." (See her painting on the opposite page.)

Erin Dertner, *Invitation to Rest*, 8 × 6 in., oil on panel, 2012.

Under Cover, 5 × 7 in., oil on panel, 2012.

Exercise—Explore Your Neighborhood

Take a walk around your neighborhood with your camera, looking for scenes that interest you. Keep an open mind. What you might first take as ugly could have incredibly interesting colors and values. Take lots of pictures. For every good one, you might have to take one hundred bad ones. When you get home, look through your pictures on your computer so you see them nice and big. Squint at each one to get a better sense of whether the composition and values are interesting (use your instinct). Choose one image, crop it, and find a painting surface with the same dimensions. You can either print out the photo or work directly from your computer screen (or iPad).

Randall David Tipton, *Slow Creek in Summer 2*, 10 × 30 in., oil on canvas, 2011.

Abstracts

I am not an abstract painter, but I am a big appreciator of abstract art. When I think of abstract art, I think of unrecognizable shapes and colors put together in an interesting arrangement, but they don't always *have* to be unrecognizable.

Randall David Tipton is a fabulous artist living in Portland, Oregon, who paints what I think of as abstract *landscapes*. He takes elements he sees in nature and combines them with his imagination, using various media and surfaces, into colorful scenes that take the breath away. They all have elements of reality, some more than others, and they are all uniquely beautiful.

"I'm not trying to paint places as they are; I'm trying to paint my experience in those places," says Randall. "The abstraction is used to emphasize those elements that attracted me. In the painting *Slow Creek in Summer*, what I was after was that torpor that is unique to summer; very little movement in the heat and the smell of the shaded damp earth. In the wetlands work I've done, I might have busy, even chaotic marks meant to approximate the teeming and diverse amount of life there. The degree of 'distortion' is determined by my subject and how I can isolate aspects of it that move me. I feel I'm most successful when my paintings allude to the landscape in a sensual way rather than literally."

Lisa Daria is another daily painter who paints recognizable objects in an abstract fashion. Her most common muse is the still life—often flowers.

She paints with acrylic in big, broad strokes for a distinctly minimalist style. The result is enchanting, as in *Table Talk* (at left).

Lisa never starts with a drawing. She says, "Drawing my composition first on the canvas makes my paintings too tight, like I'm trying to fill in the lines." Instead she relies on "an economy of strokes to record only the essential form and structure of the subject. I'm not interested in the details, so I concentrate on using a minimal amount of shapes, marks, and colors to define what is in front of me. This results in paintings that look loose and abstract." Lisa is truly a *daily* painter and an inspiration for us all. "I mark every single day with a painting (even Christmas!)" she says. "I get up at five to do my daily painting and if I'm short on time, I'll do a smaller, 4 by 4 inch painting. Having had cancer as a young adult, I discovered living is not just surviving, and the small, intimate paintings create a structural framework of self-preservation."

Elizabeth Chapman is a more traditional abstract artist. She uses thick strokes of acrylic paint in various colors and puts them together in deceptively simple combinations and arrangements. She uses a variety of hard and soft edges and simple geometric shapes to create large and small works of art that will charm even nonfans of abstract art. Elizabeth is inspired by many things, including "music, sites and scenes, memories, other artists' work, colors, people, and even good food!" When I asked Elizabeth about her process she said, "Once I begin I have found it important to follow the flow of the painting. Trying to force the painting into something that it isn't only leads to much frustration. It's kind of like a dialogue between myself and the work, where I listen to what it has to say and then respond with lines, shapes, colors, [and so on]."

Some daily painters have harnessed the joy of coordinated, abstract doodling, which works well in a small format. **Carmen Beecher** is one of these artists and has created *Carnival* (at right), a fun little drawing with pen and ink on paper.

"As a daily painter," says Carmen, "I spend my time drawing, painting, or collaging. I also spend some time chasing new art forms, but I try to control that, since there are only so many hours in the day. If an oil painting is not going well, or if I have just spent many days painting similar things, I will sometimes get all Zen with a Pen and create a fanciful place of my own. It is a very meditative discipline, and I never know where it's going until I am there, as in my drawing *Carnival*, which started as a big squiggle."

Elizabeth Chapman, *Piquant*, 8 × 8 in., acrylic on canvas, 2012.

Carmen Beecher, *Carnival*, 8 × 10 in., pen and ink on paper, 2013 (inspired by Zentangle®).

Lisa Daria, *Table Talk*, 6 × 6 in., acrylic on board, 2013.

Value

Value is the lightness or darkness of a color, and possibly *the* most important element in depicting three-dimensional objects and creating interesting images, no matter what medium you're using or what subject you're painting! This is especially true for daily painters who sell in online galleries, because their images need to read well and be enticing enough as little thumbnails for viewers to want to click to enlarge (and, hopefully, buy) them. Value plays a big part in whether a small image *pops* or not—and for that reason, I think it's a huge part of what makes a daily painting displayed online successful or not.

Also, if you create a composition with accurate and interesting values, you can really play around with—that is, use your artistic license to change, adjust, emphasize—anything else (proportion, color, tightness/looseness, etc.). If you have the values down, the world will be your oyster.

Accuracy

To be accurate with value you must constantly compare *every* value with *every other* value in your subject rather than just values that are very near each other, which is our tendency. This is where squinting becomes essential. I can't say it enough. Write it down and tape it to your easel—"Squint!" Don't take it down until squinting has become second nature and you've got some major squint lines around your eyes (I swear this part is worth it for the sake of art!). I like to close one eye and squint the other. I've had students simply take off their glasses.

Squinting allows you to see the entire subject at once, or as I like to call it, *the big picture*. We tend to mentally zoom in on one area at a time, and squinting forces us to zoom back out. It also blurs the details, which prevents what I call "detail-itis." Details can be important for a painting, but they can also prevent us from seeing that big picture at the start of a painting.

Getting the values right is by far the *biggest* thing I have to help my students with. My advice is—if you have any trouble with value, spend some time with charcoal, paper, and some simple subjects. Work from life (because cameras skew value a lot) and before you begin, ask yourself: Where is my darkest value? Where is my lightest value? Where do the others fall on the value scale? How do all the values relate to each other?

It can be helpful to simplify the values into big shapes in your head so they're easier to deal with. If you can break them down into four to six main values per setup/reference, you'll be doing yourself a favor. You're basically trying to create a *value map* in your head before you start, so you're clear about how to proceed.

In the first (top right) example I've divided the cup into four main values, but really there are five if you include the highlights. Since the highlights are always the lightest (and so small), I like to think of them as zero. A common mistake with my students is to make their number 1 as light as the highlights, which means the highlights don't "show up." This is one advantage to working on a white palette—I can always compare my number 1 color to white to make sure it's different enough from what will essentially be the value of my highlights.

Seeing values clearly in grayscale is a lot easier than seeing them in color, but the process is the same. Squint, compare, and map. The colors may be different in the example with the teapot and cup at right, but the values still map. For example, in this case the background in the light is the same value as the shadow cast from the cup. If you squint it becomes easier to see.

Getting values right takes a lot of practice *seeing*. As you go around in your daily life, practice by looking around at everything and comparing values. Squint—but not while driving!

1. Sample still life in black and white—white cup and spoon. **2.** Sample still life divided into four main values (five including the highlights)—a *value map*. See how the values repeat?

3. Sample still life—yellow teapot and mug. **4.** Sample still life divided into five main value areas (six if you include the highlights)—notice that some values repeat themselves, even though the colors are different.

Interesting Value Composition

Someone told me long ago that if you vary the amounts of each value in your composition, you can create more dynamic paintings. So what does this mean? To make it simple, let's say you have only three values, light, mid (middle tones), and dark, and you arrange them so you have an even amount of each. This gives you a pretty boring result (see Figure 1).

But if you instead have one value take up more than half the space, another take up more than half of what is left, and the last take up just a little bit, this gives you a much more interesting value composition. I call these dominant, secondary, and smidge values (see Figure 2).

Now to make this just a little more complicated, let's expand our values so that instead of just three we consider the *entire* value range.

1. Three values: light, mid, and dark, divided evenly—boring!
2. Three values: light, mid, and dark, divided unevenly, into dominant, secondary, and smidge amounts—more dynamic!

darks mids lights

The entire value range, divided into darks, mids, and lights.

You are in full control of your value composition, especially with still life, depending on what subjects you use, the value you choose for your background, how you angle your light, how you crop your subject, and so on. You can create a different mood depending on how your values are arranged. For example, a dark-dominant painting (remember, this means the dark values are taking up the most *room* in the painting) often creates a dramatic or somber mood. A light dominant painting can have a lighter, often playful atmosphere (see examples on the next page).

Keep in mind the eye is going to tend to focus on the smidge, or smallest value. If you go out into a field of black sheep with one white sheep—where do you look? The white sheep.

Another one of my paintings, also desaturated. The dominant value here is dark, secondary is mid, and the smidge is the light. Getting the hang of it now?

One of my paintings, desaturated (without color), so you can only see the values. The dominant value (the one there is the most of) is mid, the secondary is light, and the smidge (least amount) is dark. Can you see it?

1. Qiang Huang, *Everlasting Rose*, 6 × 6 in., oil on panel, 2013.
2. *Everlasting Rose*, desaturated. This painting is dark dominant, mid secondary, and light smidge, giving it a dramatic feel.

1. Oriana Kacicek, *First Kiss/True Love*, 6 × 6 in., oil on linen, 2013.
2. *First Kiss/True Love*, desaturated. This painting is mid dominant, light secondary, and dark smidge, which lends to its light, playful atmosphere.

Exercise—Value Study

Set up a still life so you have dominant, secondary, and smidge values. Use a viewfinder to find your composition. You can paint all the values *you* see—you don't have to stick with just three—the idea is to categorize them into three values in your head: darks, mids, and lights. If you are using oil, there are two ways to do this exercise:

1. The first way is to tone your panel or canvas with burnt umber and a little OMS, wipe it down to a mid-value with a paper towel, paint in the darks, and wipe out for lights with paper towel or Q-tips (try dipping in OMS for the really white stuff).

2. The second method (which also works for acrylic) is to mix a range of three values between black and white, using straight black and white for your fourth and fifth values.

The goal of the exercise is to establish all the values as accurately as you can while also maintaining the recipe (dominant, secondary, smidge). Try timing your attempts. In class we do this exercise three times with a different composition for each: the first one for twenty minutes, the second for ten, and the third for five. Repeat as often as necessary. It can take a while for this concept to sink in!

Value study exercise 1: Tone your board or canvas—I am using oil and method 1 in the exercise, so I toned it with burnt umber.

Value study exercise 2: Draw your composition with straight burnt umber and a small brush.

Value study exercise 3: Begin wiping out your lights with a paper towel. If you dip it in OMS first, more burnt umber will come off when you wipe.

Value study exercise 4: Done. Now check to make sure your values match those in your original plan. This one is light dominant, mid secondary, and dark smidge.

This recipe (dominant, secondary, and smidge) is just *one* way to arrange your values, not *the* way, but it will hopefully make you think more about the importance of the value composition.

I find that most of the time I can trust my instinct to find interesting value compositions. I start every painting by planning out my composition, and I do that by simply playing around with my subjects in my shadowbox. While I do this, I am looking through my handheld viewfinder (more about this in chapter 6) for interesting angles and compositions. "What if I crop that? What if I stand over here?" I am also squinting a lot and asking myself, "Are the values interesting?"

A big problem I try to avoid is having an important element of my composition disappear because a nearby element has a similar value. For example, if the background is a mid value, and my star subject is an apple of the same value, even if they are different colors, the apple will disappear. Sometimes the solution is to change the angle of the light so the apple stands out more, and sometimes it's better to simply change the background value (see example at right).

Also be aware that the eye tends to gravitate toward areas of greatest contrast. That means that wherever you have a light value butting up against a dark one, that part of the composition is going to draw attention. Make sure that doesn't happen in an awkward spot, like too near an edge or right in the middle of the painting.

So remember this about values:

- Value plays a very important part in whether or not your image is dynamic.

- Value is particularly important for daily painters, who paint small works that need to stand out as a thumbnail when online.

- You are in control of your value composition.

- Be on the lookout for variety in your values.

- Avoid letting important elements disappear because their values are similar.

- Make sure the biggest contrast is on or near the focus of the painting.

1. If the tomato is the star of this composition, it disappears in the shadow of the cup, because the shadow and the tomato are the same value. You can see this clearly if you squint. **2.** By repositioning the tomato, we save it from a life of obscurity and return it to its rightful place in the spotlight.

Color Mixing

A daily painter who doesn't know how to mix color well will spend far more time painting "wipers" (paintings you end up wiping off afterward) than creating paintings worthy of posting. I mostly learned about color mixing on my own, through experimentation, and it took a long, long time. There is a much simpler way to think about color, in my opinion, and I hope it will make sense to you as well.

I will explain this in terms of color in general. Although some of it will be oil specific because that is my medium, the concepts will apply to any medium.

Saturation

Saturation is the relative *intensity* of a color, or chroma. This is different from value, which is the relative *lightness* or *darkness* of a color. Every color has both a value and saturation. It is somewhere on a scale from light to dark and either very saturated/intense or not very saturated (a completely unsaturated color is gray) or somewhere in between.

For now let's talk about color in terms of a big circle, the color wheel.

We'll start with the three primaries: red, blue, and yellow (opposite page, top right). This may seem simple, but it is very important. If we have just one of these three (and it's a completely pure version of that color), we have a very saturated color. If we mix two together, the result is a secondary color (purple, orange, or green), but it's still saturated (this gets a little more complicated with paint, but let's keep it simple for now). In essence, we are locating colors around the *outside* of the circle.

A sampling of very saturated colors.

A sampling of the same general colors, but this time less saturated.

If we take any of these secondary mixes and add the third primary from across the wheel (for example, take orange—a mix of red and yellow—and add a little blue), we are moving *inside* the circle, and our color becomes less saturated. In theory, an even mix of red, blue, and yellow is completely unsaturated. Note: to get the color in the very middle of my example, I added some white.

Exercise—Color Mixing

Try this out. Mix cadmium red and cadmium yellow light to make a nice orange. Leave that pile alone. Now mix another that is just the same but add just a little ultramarine blue. See how the new pile is now a less saturated orange? Add more blue to experiment, and then try it with the other secondaries. Play around with your paint. Get a feel for what it does.

1. The color wheel in paint, showing only the three primaries: red, blue, and yellow. **2.** Now adding the three secondaries: purple, orange, and green. The colors so far are all saturated and located around the *outside* of the wheel. **3.** Now adding a little of the third primary (that is, the primary directly across the wheel) to each of the secondaries. This moves our colors inside the wheel and makes them less saturated.

Starting with cadmium red medium, straight out of the tube (at top), I added more and more yellow and blue (in even amounts) to get a grayer and grayer red.

The Oh-So-Important Gray

I like to think of everything in the middle of the circle as "gray." Basically any color that is a mix of all three primaries (even if the amounts are uneven) is gray in Carol-speak:

"Gray" = Blue + Red + Yellow (and maybe white)

Maybe a better way to think about this is that some colors are grayer than others. Here's an example starting with a very saturated red at the top (cadmium red medium, straight out of the tube)—then adding more and more yellow and blue (cadmium yellow light and ultramarine blue—in fairly equal amounts) to make the red grayer and grayer. In this example, the reds are also getting darker because the blue is darkening the mixture more than the yellow is lightening it.

I can't tell you how often in class I am painting a demo and someone asks: "What colors did you use to mix that color?" The answer is most often "red, blue, and yellow" (and maybe white). By the end of a workshop, half the class answers the question for me. They've even made T-shirts for me with the answer on the back.

So now that you know how to mix the grays, it is important to note that these grays are what make the saturated colors stand out. Most beginning artists fall in love with color and want to exaggerate *all* of them. There is nothing wrong with this, but through experience I have learned that *too* much saturated color makes *no* color stand out. So instead of complaining about mud in your paintings, harness the grays! They are often like a supporting cast—there are many more of them than stars, and they can make or break the movie . . . I mean, painting.

In the first example opposite, the saturated colors overwhelm the composition. It's not clear where the focus is because everything is shouting at us. In the second example, I've removed the saturated paper and replaced it with a less saturated version. I've also replaced the yellow cup with a white one (white is essentially gray). For me, this is a more pleasing composition. The tomato can shine and is balanced nicely with the green cup. If you can use this concept in your daily paintings, they will stand out more on a page filled with other paintings that don't use it.

Something I've noticed about shadows is that they are *all* gray. That means every shadow you ever mix is going to include red, blue, yellow, and maybe white. And this includes both kinds of shadows: form (those *on* objects) and cast (those *cast by* objects). I'm not saying all shadows

are gunmetal gray—just that the mix will include all three primaries and maybe white.

When you bump up against a color you can't quite put your finger on—it's most likely gray! It might be gray-green or gray-orange or any number of other grays, but it's probably gray.

I use a limited palette with just the three primaries (plus white and burnt umber). I don't use any secondaries because I know I can mix them. Fewer colors make things simpler for me, in terms of buying paint *and* mixing it. I don't have to rely on recipes because every color is made from just a few basic elements.

The Way Paint Leans

Unfortunately the reality of paint is a little more complicated than the theory, because there is *no* pure color in paint! Every color leans toward other colors—in other words, every color has little bits of other color(s) in it. Here is my palette and how each color leans:

- Cadmium yellow lemon—yellow with a little blue in it

- Cadmium yellow light—yellow with a little red in it

- Cadmium red medium—red with a little yellow in it

- Alizarin crimson—red with a bit of blue *and* yellow in it

- Permanent rose—red with a little blue in it

- Ultramarine blue—blue with a little red in it

- Phthalo blue—blue with a little yellow in it

*Note—I use Utrecht professional-grade paint. Other brands may vary a bit. For example, I know the cadmium yellow light for both Gamblin and M. Graham Co. is like my cadmium yellow lemon, and their cadmium yellow mediums are like my cadmium yellow light.

1. In this example composition, all the colors are saturated—everything wants to be the star, so nothing is.
2. In this second example, there are far fewer star wannabes because I've replaced a few objects with less saturated versions.

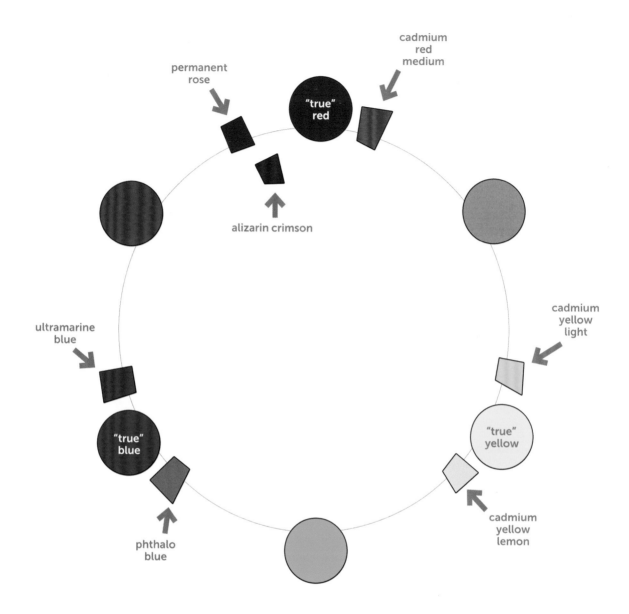

An approximation of where each of the colors on my palette lands on the color wheel. By *no* means precise!

If you want to mix a *saturated* secondary, you have to be careful which colors you use since, if you inadvertently add a third primary to the mix, it will become more gray and less saturated. So, with my palette, I would mix these colors to make the most saturated versions of the three secondaries (orange, green, and purple):

Cadmium yellow light + cadmium red medium = most saturated orange

Cadmium yellow lemon + phthalo blue = most saturated green

Permanent rose + ultramarine blue = most saturated purple

Get it? If not, there is a book called *Blue and Yellow Don't Make Green: How to Mix the Color You Really Want—Every Time* by Michael Wilcox that explains this concept in great detail and includes most brands of paint and how each color leans.

With my limited palette I feel confident I can mix just about any color I see. Obviously I can't make straight (pure) red, yellow, or blue because those colors do not *exist* in paint. But because I have the basic building blocks, I can mix a huge range of colors rather than buying that same range of tubes.

Challenge What You Think You See

Things aren't always what you think they are. Often we think of colors (and want to mix them) as brighter and more saturated than they are; in reality, they often need to be darker and/or grayer.

For example, take a good look at the apples on the next page. We tend to *think* of apples as red, so when we see them we figure we'll pull out our good ol' trusty tube of "red" and start painting! But these apples, in particular, are too dark for straight red (I'm thinking of cadmium red here) out of the tube.

Here at right is the same exact painting, with the words "straight cadmium red" the color of, you got it, straight cadmium red (or as close to it as I can manage with Photoshop). Hopefully you can see that if I had used this color for my apples, they would have been too light and too saturated. To make the apples a darker, grayer red, I started with my cadmium red and added ultramarine blue. Because there is some yellow in my red already, the blue I add is the third primary, which is making a grayer red.

Unfortunately, mixing the right colors is harder when you're working from life than from photos. We tend to get distracted by the huge variety of subtle colors we see in life, whereas a photo is a flat, simplified version of a scene, and we can interpret those colors more easily. As an aid, I recommend using objects around you to compare with colors in your setup. For example, I could have held a bright red object right next to my apples, in the same light, to see the difference between the reds.

This problem with seeing is especially prevalent when we're looking at reds, oranges, and yellows, for some reason. We tend to see these colors as too light and paint them that way. I find myself going back and darkening these colors on a regular basis—though now, since I expect it, I take a good hard look right at the start and sometimes make them a little darker than I think I should, just to compensate.

For me, egg yolks have always been especially tough in this way. My brain tells me the yolk is "yellow"—everybody knows that! But if I use straight cadmium yellow light (my instinct), the color is way too light and too saturated. If I mix a gray yellow (using cadmium yellow light, alizarin, and ultramarine blue—three primaries—*not* the be-all and end-all formula for egg yolks!), then I get much closer to the true color.

Here is one more example. As described above, when we look at an apple, our brain says "apple equals red." The first apple at right is an approximation of a total beginner's attempt. It is made from straight cadmium red with a little burnt umber to make the shadow. The second contains absolutely no straight cadmium red but instead is made up of mixes of red, blue, yellow, and sometimes white. Which one looks more realistic to you?

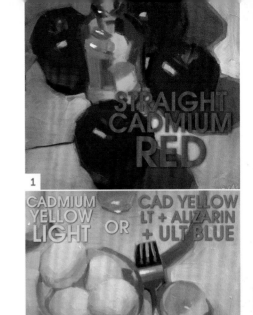

1. *Beloved* again, showing the comparison between straight cadmium red and the grayer, darker red of the apples. **2.** *Straight Up Egg,* 5 × 7 in., oil on panel, 2013. Comparing yellow, straight from the tube, and the colors that actually make up this yolk (yellow, red, and blue).

3. My approximation of a beginner's apple, using colors straight out of the tube. **4.** A more advanced apple, using more sophisticated mixes of color.

Beloved, 6 × 6 in., oil on panel, 2013.

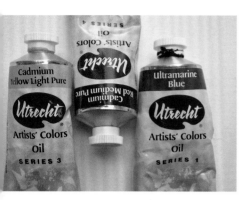

My "workhorse colors": Cadmium red medium, cadmium yellow light, and ultramarine blue.

Color Chart

When I first learned that colors leaned (years after college) I thought, "Why haven't I heard this before, it is so fundamental!?" And then I thought, "How the heck am I going to remember all this?!" But honestly it took about two weeks for it to sink in, and now it is second nature.

Hint: Write your colors and how they lean on a strip of paper and put it directly above your palette for reference.

Pop Quiz: So to mix a gray, what colors do you use? Answer: Any red, yellow, and blue, and maybe white. I have found that most of my grays start out with cadmium yellow light, cadmium red medium, and ultramarine blue because they are all about the same opacity and intensity. I call these three my "workhorse colors."

Keep in mind though that you can use *any* red, yellow, and blue to make gray—it doesn't matter how they lean when you're making gray because any of them will give you all three primaries.

White, Brown, and the Trouble Colors

White

I don't want to make anyone afraid of white with this next part, so bear with me! I had a professor in college tell me I used too much white, after which followed five years of what I now call my "dark period."

That said, one should be careful not to add white where it isn't needed. For example, if you're mixing a really saturated color (as in the light sides of the apples on page 74), white will tend to make your color chalky. I used cadmium yellow light and cadmium red medium to mix these saturated reds and oranges, and I didn't use any white until I got to the highlights (and a little in the reflected light on the sides of the apples).

There are many situations where white *must* be used. For example, to paint the flower on page 75, just about every single color mix had white in it (plus red, yellow, and blue—that's starting to sink in now, right?).

If you can't quite get the color light enough without adding white, but white makes it chalky, maybe it doesn't need to be so light! Maybe the values around it simply need to be darker. If you're *sure* it needs white and it still looks chalky, try adding a little yellow and/or red.

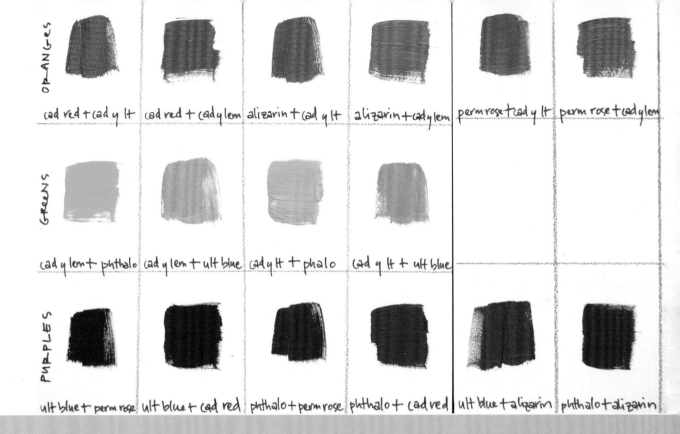

ORANGES	cad red + cad y lt	cad red + cad y lem	alizarin + cad y lt	alizarin + cad y lem	perm rose + cad y lt	perm rose + cad y lem
GREENS	cad y lem + phthalo	cad y lem + ult blue	cad y lt + phalo	cad y lt + ult blue		
PURPLES	ult blue + perm rose	ult blue + cad red	phthalo + perm rose	phthalo + cad red	ult blue + alizarin	phthalo + alizarin

Exercise—Color Leaning Chart

On my palette, I have two yellows, three reds, and two blues. Mixing two of these at a time gives me six oranges, four greens, and six purples. This exercise illustrates how these mixes are different from each other, depending on the paint and which way it leans. Divide a panel (or two) into three rows and six columns and make the chart above, with the most saturated combinations on the left. The color differences are subtle and don't reproduce well here, unfortunately (especially the oranges!). When you get to the purples, add a little white to each mix or they'll be too dark.

Next pages: *Race to the Top,* 6 × 6 in., oil on panel, 2012. Be careful not to add white when you need your colors to stay super saturated. *Creamy Layers,* 6 × 6 in., oil on panel, 2012. Don't be afraid of white. Sometimes you need to use a lot of it.

Burnt Umber

I include burnt umber on my palette for three reasons. Sometimes I like to use it for my ground (underpainting), I always use it for my drawing, and sometimes I combine it with ultramarine blue to get a dark that is close to black. I never *ever* use it to mix any other color, even brown. I can get much more interesting and varied browns by mixing them from scratch. How do I mix brown? Red, yellow, and blue, of course.

Alizarin Crimson and Permanent Rose

Earlier in this chapter, I mentioned that alizarin has little bits of yellow and blue in it. It is therefore a *gray* red, since it contains all three primaries. But it is also a translucent red. This makes it pretty useless for darkening colors that you want to keep opaque, for example, the shadow sides of apples (I use ultramarine blue and cadmium red medium instead). But alizarin is great for making thin darks (with ultramarine blue and cadmium yellow light), and subtle, pinky or peachy lights (with white and maybe some cadmium yellow light).

Permanent rose is essential for making any kind of saturated pinks or purples. For example, I *had* to use it for the rose painting opposite. I don't find I often have a need for saturated pinks and purples, so I don't always put it on my palette. But I keep it handy.

Towards Romance, 6 × 6 in., oil on panel, 2011. I used permanent rose to create these saturated pinks.

Phthalo Blue (the Priceless Troublemaker)

If you've never played around with phthalo blue, take some time to do so. If you've already battled with it and given up, give it another chance. To say phthalo is a *strong* color is a bit of an understatement. But it is also incredibly useful for mixing blues, greens, and turquoises. You won't be able to get the same variety of these colors without phthalo. Here's the key—*you only need a tiny little bit*! So be careful with it.

In the example opposite with the bottles, the one on the right was made mostly with ultramarine blue, but the other two couldn't have been made without phthalo.

Some of my students tell me they bought phthalo on my recommendation but find they never use it. Perhaps they don't love turquoise as much as I do and so don't often have a need to paint with it (just as I often don't mix purples or pinks), and that is something to consider when you're buying paint.

Exercise—Paint Mixing

Visit your local home improvement or paint store and get some paint card samples. It doesn't matter which colors, but try to get a variety. Bring them home and set one up about five feet away from your palette, in the same light that is on your palette or as close to it as possible. Try mixing a color to match a card color. Put a mark with the color you mixed directly on the card. If it's not a match, try mixing it again, this time with the card right there on your palette. Repeat the exercise with the other colors. And then repeat it again, with any of the colors, as needed.

The Crew, 6 × 6 in., oil on canvas, 2011. Phthalo blue was essential in mixing the colors for these bottles.

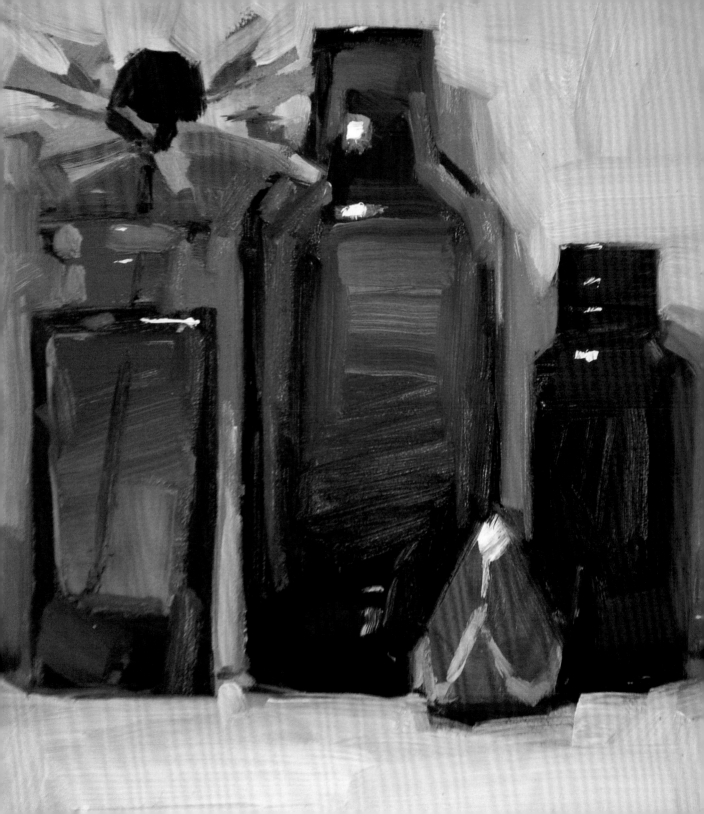

6

Drawing and Proportion

Most amateur art I see is bad either because the values are incorrect or the proportion is off. Incorrect proportion is especially noticeable when viewing a small thumbnail of a painting online, which makes this an important skill to master for daily painters. The absolute best way to get better at this is to practice!

I carried around sketchbooks all through college and drew every chance I got. I filled one sketchbook for each of the four years I was there. My first sketchbook is embarrassing! Fortunately, I lost that one when my house burned down. Unfortunately, I lost all the others as well. By a stroke of luck I was preparing for this lesson about a week before the fire, and managed to get a picture from each of my first and fourth year sketchbooks to show side by side (at left).

I would argue there is a pretty big difference in maturity and style between the two. In the earlier drawing, the proportion is appalling, the marks are completely inconsistent from one section to the next, and the style lacks any confidence. The later drawing is a self-portrait and while it still has some proportion issues, it is far more realistic. The composition is more resolved, and the marks are clean and confident. You too will see improvement if you draw every day.

Go today, get yourself a sketchbook, and carry it around with you. Sketch whenever you have a chance, even if it is just for twenty minutes while you're waiting for your oil to be changed or at the airport. When there is nothing else, draw your hand! It is always happy to oblige.

1. A sketch of my first room-mate, Holly, in college, 1996.
2. A self-portrait from my last year of college, 2000.

Examples of my own hand, always the left—the right is busy.

Exercise—Draw Your Hand

Find a comfortable spot to settle in for an hour or so and draw your hand in various positions. Don't think of your fingers as fingers—try to simply draw what you see. Squint if that helps. For more contrast, sit next to a strong light of some kind. If your hand gets tired, try positions where your hand is resting on something, like the table or the arm of the couch. Try holding something in your hand.

Use a Viewfinder

If you are working from life, you'll want a viewfinder—a simple device that enables you to frame whatever it is you're drawing, painting, or shooting. It's important for several reasons, the biggest being that you can find your composition with it. This is important for all art, but especially important for daily paintings, because you're working with a relatively small area, and every inch of the composition needs to be resolved. Without a viewfinder, you're just *guessing* where everything goes on your canvas, which often results in everything landing right smack-dab in the middle (boring).

- **How do you make a viewfinder?** Cut a square or rectangular hole in something with a stable surface (like cardboard or cardstock). The hole should have the same proportions as your canvas or panel. You can use an online proportional scale calculator to help you get the size of the hole right. I recommend it because you want it to be as exact as possible! Or you can *buy* a viewfinder. I have an adjustable one called ViewCatcher. It's great when I'm traveling, but I like my simple, cardboard ones at home because I have lots of different sizes for different kinds of setups. If you find you are holding your viewfinder very close to your face, you probably need a bigger one. If you find you can't quite hold it far enough away, you probably need a smaller one.

- **How do you use a viewfinder?** It's the same concept as the viewfinder of a camera. Simply hold it up in front of whatever you want to paint and close one eye. What you see inside your square or rectangle is what you'll paint, so make it look good there first.

The hard part about using a viewfinder is getting it back into the same place every time you look back at your subject. I don't really find this to be a problem, but a lot of my students do, and for this I recommend a device that will hold your viewfinder in place—an adjustable "arm" with clamps on both ends (Google "arm with dual clamps"). Attach one end to something solid, and use the other to hold the viewfinder. Then all you have to worry about is getting your head back in the same place every time. You will see an example of this device on page 84.

A few of my viewfinders, including the adjustable ViewCatcher (gray).

An example of what you'll see looking through your viewfinder.

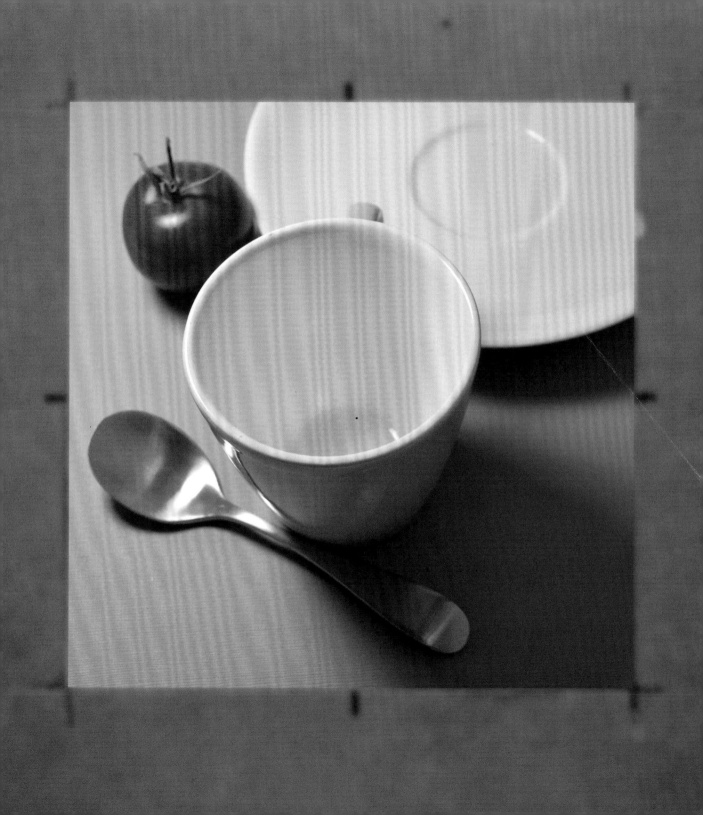

1. If you have trouble getting the viewfinder back in the same place every time, this is a handy tool to have. **2.** Me using my viewfinder. **3.** Corresponding halfway marks on my panel and viewfinder.

What I do is spend a good amount of time working out my composition and then a good bit *more* time becoming familiar with it through my viewfinder. I take note of each edge and how close each object comes to it—or where each object is cropped by an edge, and so on. As I'm drawing, I make sure at least one of my feet is in the same place the whole time, and I keep my left elbow clamped to my side in the same spot (if I'm looking down at my composition) so I can hopefully keep the viewfinder in the same general spot. After I draw my setup, I generally don't need my viewfinder anymore for that painting, unless I need help judging perspective (more about that later).

I like to put marks along the edges of my viewfinder at the halfway points. I put corresponding marks along the edges of my canvas or panel (see image 3). Then, as I am looking through my viewfinder, I find the outside edges of my objects and figure out where they are in relation to the halfway points. (This is the same principle as gridding a canvas but a bit less time consuming and not as obtrusive.) I make small marks on my canvas to indicate these edges of objects. And then I work my way in with my drawing, from simple to more complicated shapes.

In the example opposite with the apples, fork, spoon, and plate, you can see how I related each mark in the beginning to the halfway marks along the edges (keep in mind I painted this from life, so the photo may be a little different from what I saw through my viewfinder). Using burnt umber, thinned just a little with OMS, and a small brush (my favorite is a Silver Brush Bristlon filbert size 2—my drawing brush), I started by drawing the boundaries of each object: top, bottom, left, and right. The bottom of the left-most apple lines up almost exactly with the halfway mark on the left side. The bottom of the middle apple touches the top mark of the fork and spoon shape, and that happens in the middle of the panel, just below the halfway mark. I generally put down the easiest marks first and then work from there.

After I establish all the boundaries, I start rounding out my shapes, making any corrections now that I can see all the objects relating to each other. Then I sometimes fill in a few of the darker values with my drawing brush and burnt umber. This is optional because it can sometimes make the next step harder, but I recommend it for beginners who don't yet have a firm grasp on value. It can be easier to establish values with this neutral color (burnt umber) and then put the "real" colors on top, making sure the values match, rather than putting on the right values later, with no value map.

Here is a scenario you might find familiar. You are drawing a still life with grapes. You draw the first grape where you think it should go. You draw

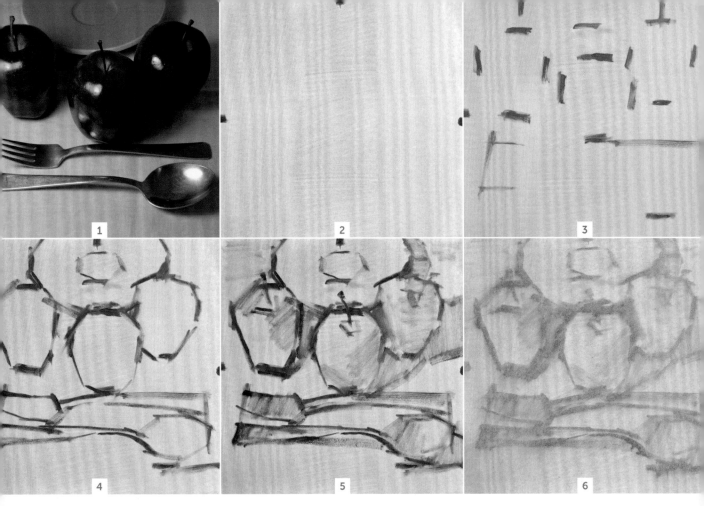

1. Setup for apple drawing (and eventually the painting, from life, which you'll see later in the book). **2.** Step 1: Tone canvas and establish halfway marks. **3.** Step 2: Establish boundaries for each object—top, bottom, left, and right—using the halfway marks to help locate them. **4.** Step 3: Round out each object. Find the fork and spoon shapes, using the negative shapes to help. **5.** Step 4 (optional): Add a few values to help solidify the drawing. **6.** Step 5: Wipe the drawing lightly with a paper towel so that only a *ghost* image remains.

the second grape in relation to the first. You draw the third in relation to the second. And so on. You get to the last grape and suddenly you realize you didn't leave enough room for the rest of the composition. Sh*t!!! But now you've spent so much time getting all those grapes just perfect. You ask yourself, "Do I really want to start over?" So you compromise and the drawing is not nearly as good as it could have been.

Here's how to start smarter:

- As described, mark the boundaries: top, bottom, left, and right of each object (or group of objects—like grapes) and where any object is cropped by the edge of the canvas.

- Work the entire canvas at once rather than focus on any individual element!

- Compare the location of each mark to as many other things as possible (including the edges of the canvas and the halfway marks)— in essence, you are triangulating to double check the location of each mark.

- Once you get everything in the right place, round out each complete object. If your objects overlap, it can be helpful to draw each object as if you could see through it.

- Get big shapes down before you draw anything peripheral like cup handles, spouts, stems, and so on.

- Once you have those big, simple shapes, work your way toward details.

- Shade in darker values if that helps—you can even do an entire value study and paint on top of that.

In my final step before painting, I take a dry paper towel and lightly wipe my drawing, leaving enough paint so I can still see a *ghost* of it (see figure 6 on page 85). The idea is to be able to see where everything goes but to wipe away the thickest parts of the paint so they don't interfere with the colors that will be put down next. If I use too much OMS with my paint in the drawing phase, I run the risk of taking too much of the drawing off in the wiping phase. The trick is to use just enough OMS to thin the paint so it's easy to draw with, but not so much that you have trouble later.

On the next page is one more example of a drawing, from start to finish, using the halfway marks to help locate the objects.

Clinton Hobart, *Apples and Grapes*, 6 × 6 in., oil on masonite, 2013.

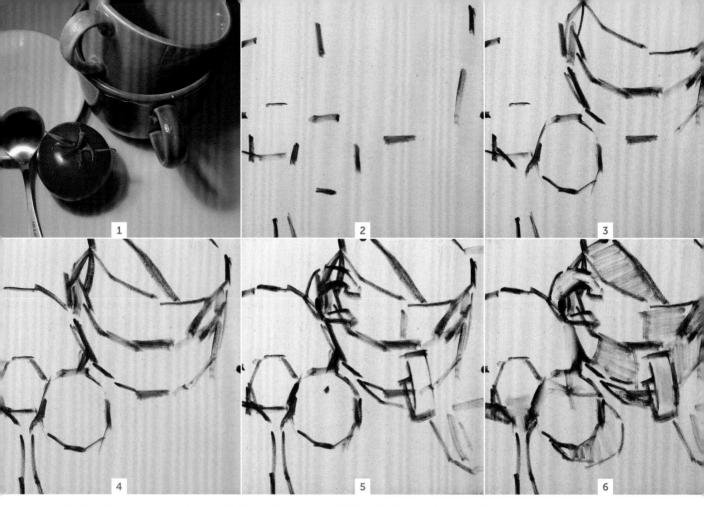

1. My setup—cups and a tomato. **2.** Step 1: I start by establishing the boundaries around each object. Note that they are simple, straight lines to locate edges and nothing more. **3.** Step 2: The ellipses of the cups, especially stacked, tilted ones, are incredibly difficult to draw accurately. I take my time with these, looking back at my reference often and comparing each part to as many different things as I can (for example, the difference in the amount of the side of the cup you can see, for each of the two cups, and the fact that the top cup has a more squished ellipse than the bottom one). **4.** Step 3: I continue rounding out the plate, spoon, and cups, and locate the shadow on the back of the top cup. **5.** Step 4: Next, I locate the handles on the cups. This is a tricky part because your brain is going to tell you what a handle *should* look like. This is where it is very important to squint and remember to draw what you *see*, not what you *think* you see. (We'll get into this in more depth soon.) Look at angles, distances, and negative shapes. Does the bottom of the handle line up with anything else in the composition? **6.** Step 5: Last, I wipe away any unneeded marks and add a little shading to indicate darker values. If I were painting this, I would now wipe the drawing with a dry paper towel until I had just a *ghost* of an image, as I did in the first example.

Ignore Your Brain

Your brain is very useful for making sense of the world. It helps you identify and categorize all the things you come into contact with. Your brain so and is flat on the bottom. Unfortunately this causes no end of problems for us artists! Since we know a cup is flat, we tend to draw it that way, even when we are viewing it from above and the bottom is clearly rounded.

To better ignore your brain, here are some things to try:

- Paint what you see and not what you *think* you see.

- *Squint!* This makes everything a little fuzzy, which helps to simplify your scene. It also allows you to see the big picture and avoid the mental zooming in that can lead to problems. You can also simply take off your glasses, if you wear them, or use a reducing glass— which makes everything smaller. Squinting is my personal go-to brain-ignorer tool.

- Always check the *relative* positions of things in your painting. Compare each object to as many other things as you can, including the edges of the painting, the halfway marks I mentioned earlier, negative shapes, other objects, and so on. If you get one thing in the wrong place, it makes everything else along the line wrong too.

- Measure proportions with your brush. Hold your arm straight out with your brush straight up and down, using the tip of your brush and your thumb to mark lengths and make comparisons (as in the picture at the top of page 90). This is especially important when you are drawing people, cups, bowls, boxes, and so on. Apples are a bit more forgiving in their proportions, though you can measure those too. But if you are drawing something like a tall cup and looking at it from above, your brain is going to tell you that the height of the cup is longer than the width of the mouth while your thumb and paintbrush say otherwise (see image 2 on page 90—more on cups [ellipses] soon).

- Use your viewfinder to get angles right. Sometimes angles can be deceptive: something that looks diagonal might actually be perfectly vertical, or vice versa. It is a good idea to hold your viewfinder straight up and down, line your horizontal or vertical viewfinder edge up to whatever angle you are having trouble with, and compare (see image on page 91).

- Use a mirror to look at your drawing backward. This helps, especially when you've finished your drawing and you're wondering

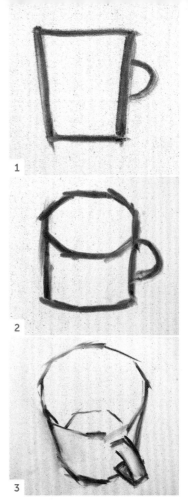

1

2

3

1. A cup the way our brain thinks of it—the way an amateur artist might draw it if someone said, "Draw a cup." **2.** This is the way a lot of my students draw a cup. The sides are parallel even though they should get closer to each other toward the bottom of the cup (this happens when you are looking down at a cup, because of perspective). The bottom of the cup is almost flat in the drawing, but it should be even more rounded than the top ellipse (also because of perspective). **3.** This is the way a more advanced artist would draw a cup. This is what happens when you can get past the "facts" your brain is telling you about the cup and really *see* it.

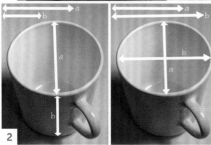

1. You can measure proportional lengths with the end of your paintbrush and your thumb. **2.** When measuring a cup with your brush and thumb, you are looking for a ratio between two lengths. I find it useful to measure the shortest length first—(b) in the first picture—calling that "1," and then see how many times that measurement goes into the second length (a), even if part of that is a fraction (like 1¾). This gives you your ratio, which in this case is 1:1¾. Then you can check your drawing to make sure this same ratio is reflected there. In this example, I recommend (1) measuring the height of the ellipse, (2) comparing that to the height of the side of the cup (as shown above in the first picture), (3) comparing the height of the ellipse to the width of the ellipse (as shown above in the second picture), and (4) comparing the total height of the cup to its total width (not pictured here).

whether to go on and paint. You may see that a vase is leaning, or the entire composition needs to be moved over to the left an inch, or something like that. A good composition works backward and forward.

- *Back up!!!!* I can't say this enough. When you back up, you see your painting smaller and often notice mistakes you didn't see when you were standing close to it. Unless you have a medical condition that doesn't allow it, I highly recommend that you stand to paint. If you sit, you will tend not to back up often enough, if at all. Toward the end of a painting, I am backing up every few strokes.

- **Mentally zoom out.** Always be thinking about the big picture. We all (even I) have to fight the urge to (mentally) zoom in and stay there.

- **See the subjects as shapes and forms.** Sometimes this simple, mental shift does wonders. Forget that your apple is an apple. See it as a series of connecting shapes, some bigger, some smaller, all with different values and colors.

- **Take a break and come back to it.** If a painting takes more than an hour or so, we tend to lose our momentum and the painting loses its freshness. When you get tired or discouraged, take a walk around the block, do some jumping jacks, or—my old standby—wash the dishes.

- **Take a picture.** I can't tell you how many times I finish painting, take a picture of it, and suddenly notice big mistakes when I see it small on the LCD panel (my vase is leaning, the shadow is too dark, etc.). Try it before you're done, and you'll still have time to make changes. (Do as I *say*, not as I *do*.)

- **Turn around and bend over.** This is a great trick for plein air painters. Look through your legs at your landscape upside down. Sometimes this gives you just the new perspective you need to figure out what you're missing. At the risk of embarrassing yourself (and possibly falling over), you could also try looking at your painting upside down at the same time.

- **Do the whole thing upside down.** If you're working from a photograph, turn it and your canvas or panel upside down. Do the entire painting that way. Do not turn it over until you're done.

Use your viewfinder to figure out difficult angles in your composition. In this example, I am holding the horizontal edge of my viewfinder near the top angle of the knife to compare.

My method for drawing a simple cup ellipse, step 1: Locate the five boundaries of the cup and its ellipse.

Step 2: Make a simple cross halfway between the ellipse's marks.

Step 3: Extend lines from the cross to the edges.

Trick for Ellipses

Ellipses can be quite difficult to draw correctly, but I have developed a method that will hopefully make them a bit easier. This method works for ellipses that in real life (that is, three-dimensionally) are round objects on a flat surface (like round bowls or plates or the tops of cups that are sitting flat on a table). It does *not* work with ellipses that in real life are oval (like the lip of an oval serving bowl) or tilted (like a lid leaning on something).

To describe the method, let's consider a simple cup without a handle:

1. When you look at the cup through your viewfinder, locate the boundaries of the cup. Start with the very top of the curve of the ellipse and mark that spot on your canvas. Then locate the very bottom of the ellipse, the very bottom of the cup, and the farthest left and right points of the cup's lip. You are going to make five marks in all to mark the boundaries of this cup and its ellipse. Bowls will require five marks as well, but a plate will only require four because you generally can't see the bottom of it.

2. Next, put a little vertical mark halfway between the two left and right marks, and a horizontal mark halfway between the marks for the top and bottom of the ellipse. The two marks should form a little cross inside the ellipse.

3. Now extend the lines of the cross all the way to the edges of the ellipse. Make sure your lines are perfectly horizontal and vertical. (There is one exception to this rule that I'll tell you about soon.)

 It is important at this step to measure the proportions of the cup to make sure your marks are correctly placed:

4. While standing in the same spot from which you've drawn the cup, hold your brush out at arm's length (lock your elbow). Line up the tip of the end of your brush with the topmost point of the cup's ellipse. Align your thumb, on the paintbrush, with the bottommost point of the cup. This is the vertical measurement of the cup. Do the same from side to side to measure the horizontal length of the cup. Note: You are not measuring the actual cup—you are measuring what you *see* from where you're standing!

Next, compare these two lengths and relate that to your drawing. To compare the width of the entire cup to the height, choose the smallest length first and call that one unit. Then see how many times that one unit goes into the longer length. If it goes into it three times, say, then your ratio is 1:3. The height and width should have this same ratio in your drawing.

These are the important distances to compare:

- Width versus height of entire cup

- Distance from top of cup to bottom of ellipse versus bottom of ellipse to bottom of cup

- Width of cup opening versus height of cup opening

5. Next you will want to draw the curve of the ellipse. It helps to know that each of the four parts of the ellipse is the mirror image of the part to the left or right of it and the part above and below it. In my experience, this process of marking the boundaries of the ellipse and "breaking" it into four parts makes it *much* easier to draw the curves.

6. The last step is to draw the sides and bottom of the cup (this drawing would be different if it were a bowl, obviously). It is important to note that the sides are almost never perfectly vertical. When the cup is viewed from above, because of perspective, the two lines get closer to each other toward the bottom of the cup. The bottom is a similar curve to the top except just a little tighter (because of perspective). Where the bottom and the sides meet there is a subtle shift from straight to curved. Many of my students tend to want to put sharp corners there, but unless you are looking at it from eye-level, it is going to be a subtle curve.

Note: If your ellipse is partly cut off by your viewfinder—if you won't have the *whole* ellipse in the painting—you've got your work cut out for you! But you can make your life much simpler by putting something you can draw on behind or beside your canvas; draw the "missing" part of the ellipse on that so you can see the whole ellipse. I do this right on my panel holder, and it makes it much easier to get the shape right.

Step 5: Round out the ellipse, making each of the four quadrants a mirror image of the one to the left or right of it and the one above or below it.

Step 6: Draw the sides and bottom of the cup, paying special attention to the angles and curves you see.

When your ellipse is cropped, it can be very helpful to draw the whole thing on something that is behind your painting/drawing surface.

Here is where I tell you about the exception to my ellipse strategy (grin). A strange thing happens when your viewpoint is from above and you're looking *down* at your setup: objects lean out toward the edges because of perspective. You can see this happening in the painting with the croissant at right. I find it easiest to think of the center of the earth as the vanishing point when I'm looking down at a still life like this. If I were to draw lines down from the bottoms of all my objects, the lines would all eventually converge at the center of the earth, and if I continue those same lines up, they lean out. This phenomenon is most visible with taller objects and in larger paintings with more stuff. In small paintings where the subject is close, the leaning is subtle but still there. The opposite happens when we look up at something. For example, think of what happens when you're downtown in a city looking up at the tall buildings: they all appear to get smaller and lean in toward each other the higher you look.

Perspective

When you are drawing three-dimensional objects on a two-dimensional surface, it is important to understand how perspective works. Basically, perspective is about the "space" (and sometimes distance) within your drawing. In my opinion the two most important features of perspective are:

- **Object size:** The farther away an object is from you, the smaller it appears to be. If you have two identical coffee mugs and place one on a table in front of you and another at the far side of the table, you can see this effect. Likewise, as objects recede in space in your drawing, they should be made smaller as well.

- **Converging lines:** Lines that, in reality, are parallel (like two curbs on opposite sides of a street) will appear to converge (get closer and closer to each other) in your drawing the further the street recedes into the distance. The point at which these parallel lines converge is called the vanishing point.

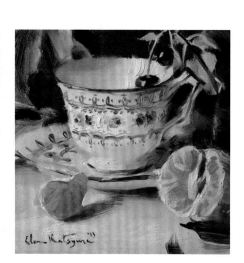

Elena Katsyura, *Teacup and Mandarin*, 6 × 6 in., oil on panel, 2013. Example of a cup with great proportions.

Continental, 20 × 20 in., oil on panel, 2010.
An exception to the ellipse strategy: When looking down at your setup, objects near the edges lean out because of perspective (especially taller objects)—subtle but important.

In the painting at left, by Sarah Sedwick, the lines of each piece of paper converge as they get further away from the viewer. Most of the time, these angles are subtle, but it is very important not to overlook them. If you can't quite tell how an angle is leaning, hold your viewfinder in front of you, straight up and down, and bring either the vertical or horizontal edge right up to the angle to see how much it's leaning.

Because you *know* when objects are actually the same size, it can be difficult to draw them getting smaller as they recede in space. Because of this it is incredibly important to measure the height and width of each object with your brush and thumb, and compare them to each other.

When It Gets Messy

No matter what I'm drawing, it is difficult to get it right the first time. I often wipe my panel several times before I land on the one I keep. If your drawing is getting messy because of too many corrected lines, wipe it off and try again. You'll be glad you did.

Even if you've spent a fair amount of time already, it is better to start with a blank slate. Chances are, your drawing will get better each time you try. This can actually be very freeing—if you're using oil, just take a paper towel, dip it in OMS, and wipe. You will feel so much better when you get it right!

If you find you need more help with drawing, I recommend these two very good books on the subject:

- *The New Drawing on the Right Side of the Brain*, by Betty Edwards

- *Your Artist's Brain: Use the Right Side of Your Brain to Draw and Paint What You See—Not What You Think You See*, by Carol Purcell

Sarah Sedwick, *Springtime Romance*, 9 × 12 in., oil on canvas, 2013. Notice how the edges of the paper converge as they recede in space—a great example of perspective.

Eggless, 6 × 6 in., oil on panel, 2012. As objects recede in space, they get smaller—in real life this sugar bowl is bigger than the cup, but because the bowl is further away, visually they are about the same width. This makes it incredibly important to measure what you see with your brush and thumb! (In this painting, I had to measure while I was drawing them to make sure.)

7

Composition

I was teaching one of my first workshops and had gotten there early to set up a composition for a demo. One of my students was early too and asked if she could watch. I hesitantly said okay, wishing I could say no. I spent the next ten minutes arranging and rearranging several small peppers and not landing on anything I was happy with. Finally, embarrassed, I turned to my student and asked, "Are you getting anything from this?" She said, "Absolutely! I am learning that even though *your* compositions look effortless, it really takes time and effort. Now I'll leave you alone."

I have learned an incredible amount about composition from doing daily paintings. When I started in 2006, I felt like composition was my biggest hurdle, but each small painting taught me as much about composing as each of the large paintings I had done before. But because I was doing so many more paintings, I was learning at warp speed!

Trust Your Instinct

The most important thing I have learned about composition is to approach each arrangement with an open mind. If you come to the table with all the "rules" in your head, they can really box you in and stifle your creativity. This is what I recommend:

- Trust only your instinct at first.

- If it looks *awkward*, keep moving things around.

- Give yourself a fair amount of time (for a 6 by 6-inch painting, it sometimes takes me two hours to come up with something I'm excited about!).

Dance of the Jalapeños, 6 x 6 in., oil on panel, 2012.

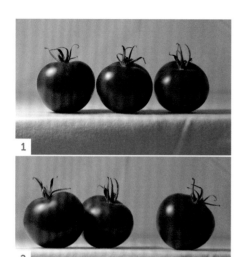

1. Boring—evenly spaced tomatoes, yawn! **2.** More dynamic—I've now unevenly spaced the tomatoes, from each other and the edge, positioning them lower in the painting, and facing different ways.

- If you've decided you're going to paint that special (insert object here) today, but the composition just isn't happening, put it aside and save it for later.

- If an element isn't *helping* the composition, take it out.

- Always be open to completely changing the setup: height of table, angle of light, type of light, color of background, number of objects, and so on.

- Don't settle on something so-so, or the painting will be so-so (okay, sometimes after two hours, I just want to paint *something—anything*, so I settle, but I usually call that a learning experience rather than a finished painting).

- When your arrangement is almost working, but not quite, it's time to consult the "rules."

The Number One Rule

I'm not going to take credit for the number one rule. I read it in a book—a *great* book—called *The Simple Secret to Better Painting: How to Immediately Improve Your Work with the One Rule of Composition*, by Greg Albert. It's the one book I would recommend if I could only recommend one. The rule goes like this:

"Never make any two intervals—of distance, length, spacing, and dimensions of shapes—the same."

Got it? Well I didn't, not at first. Basically what he's saying is—the human eye loves variety (sound familiar?). We don't *want* to see even spacing—we want to see different shapes, different sizes, different distances between objects, and so on. You will find many examples in the *Simple Secret* book, and here are a few of my own.

In the first example at left, we have three tomatoes right smack dab in the middle of the picture horizontally. All three tomatoes are evenly spaced from each over and from the edges of the picture.

In the second example, the tomatoes are shifted slightly so there is more room above and less below. They are also now different distances from each other and the edge, two are overlapping (making one essentially smaller and one larger), and one is pointed in a different direction. Now the tomatoes have personality!

In the next example, at right, the cups are the same width and height, the handles are pointing in the same direction, and on both sides, the cups are the same distance from the edges of the canvas.

In an attempt to liven up the cups, I added several new sizes, stacked them up so they are different heights, overlapped two stacks, and moved one cup off away from the others. You will also notice there are different amounts of room on either side of the composition as well as above and below. This isn't always necessary, but it can help. I also added the little tomato for a pop of color. Notice that it isn't right in the middle, horizontally.

The glass example (image 3, below right) is fairly boring for a number of reasons. Even though each object is a different height, the perspective is such that the vase and cup meet at the top edge. This is called an unfortunate tangent, and I see it happen all the time in student work (more about this later). The jar on the left seems completely unassociated with the other objects, and the "horizon line" is just about in the middle of the composition. Overall the composition seems boring and unresolved.

To make it better, I used a blue plate instead of a white one, to add more contrast. I also chose a higher perspective so none of the objects lined up in funny ways. And I added a fork for a little variety. Notice that the "horizon" is now higher and the composition is no longer cut in half. There is still one, little unfortunate tangent. See if you can find it (hint: look near the bottom of the vase).

Applying the One Rule to Other Things

The really cool thing about the concept of variety is that it can be applied to many more things than just size and distance. For example, as described earlier, varying the amounts of value in your composition can make it much more exciting.

Here are more things to which you can apply this rule:

- Color
- Saturation
- Soft and hard edges
- Direction and size of brush strokes
- Warm and cool colors
- And more . . .

1. Boring—two similar cups, spaced similarly—wake me up when it gets exciting. **2.** More dynamic—a variety of cups, stacked to different heights, different distances apart, and what's that splash of color?—now we're talkin'!

3. Boring—the composition screams awkward, from the unfortunate tangent where the tops of the glass and vase meet to the centralized horizon line. **4.** More dynamic—because the objects are the same height, changing the perspective reduces the likelihood of unfortunate tangents, the plate adds contrast, and now all the players relate to each other—cool.

I am always finding new ways to apply the One Rule: if there is anything you can quantify in your painting, try making it so that one thing happens a lot, and the other happens less. It is as simple as that, but oh so useful.

Color

A great example of using a variety of colors is in this beautiful painting by Karin Jurick, *Going Swimmingly* (at right). She uses a dominant amount of blue in varying shades and a lesser amount of orange. It makes for a very dynamic image.

Please note that most of the colors in this example are fairly saturated, but they don't have to be for this to work. In fact, I often tone down my dominant color(s) (that is, use less saturated versions), and pop the "other" color(s) (make it more saturated).

Saturation

Brian Burt has created an excellent example of variety of saturation in his painting *Squash* (at left). All the colors in the painting are very toned down (gray, not saturated) except the bright green of the frog. Pop!

Soft and Hard Edges

Laurel Daniel does a beautiful job varying her edges, especially in her painting *Clear Day Study* (see page 104). You can see that most of the trees and bushes (in the foreground) are sharp against each other and the sky, while the small, distant tree line is so soft it fades right into the sky, suggesting atmospheric perspective.

Direction and Size of Brush Stroke

I get asked about brush strokes all the time in my workshops. "How do you know what direction to put each stroke?" Unfortunately there is no formula for this, for me it is simply . . . instinct. But I am always thinking about variety! I don't want all my strokes to go in the same direction, or be the same size. I try to make some smaller or bigger and longer or shorter, depending on the space I need to fill with paint. For example, backgrounds usually require bigger and longer strokes, while highlights generally require smaller and shorter ones.

Brian Burt, *Squash*, 6 × 6 in., oil on board, 2011. Example of variety of saturation.

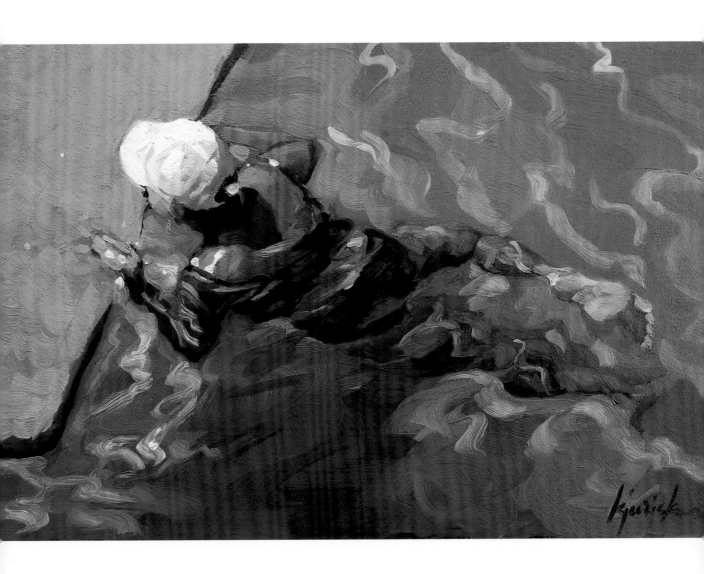

Karin Jurick, *Going Swimmingly*, 6 × 3 in., oil on board, 2012. Example of variety of color.

Kimberley Santini has demonstrated brush stroke variety magnificently in her painting, *Blue Skies* (at right). The background, which takes up most of the room on the canvas, is made with big, smooth strokes, which brings all the focus to the dog, which is a collection of short, colorful strokes.

Warm and Cool Colors

In her painting *A Beautiful Day Awaits* (below right), Dreama Tolle Perry has used a small amount of luscious warm colors, brilliantly balanced by the cool colors in the shadows. Yummy!

For more examples of warm-and-cool-balanced paintings, there is a great book called *The Yin/Yang of Painting: A Contemporary Master Reveals the Secrets of Painting Found in Ancient Chinese Philosophy*. I found it years ago and was entirely captivated.

There are really infinite numbers of things you can apply this concept of variety to. Here are a few more ideas:

- More and less visual energy
- Paint thickness
- Transparency and opacity
- And more . . .

To Remember

Don't think you have to use *every* rule *all* the time!! I made that mistake years ago. You don't *have* to use any rules *ever*. In fact rules are made to be broken. But if you use just *one*, even if it is an accident, it will probably help your paintings be more dynamic. Remember:

- Listen to your instincts—if you're breaking a rule but you like it, break the rule anyway.
- If you're going to break a rule on purpose, do it with gusto!
- Avoid anything awkward—if *you* think it's awkward, so will the viewer or potential buyer.

Kimberley Santini, *Blue Skies*, 5 × 8 in., acrylic on canvas, 2012. Variety of brush stroke sizes/directions.

Dreama Tolle Perry, *A Beautiful Day Awaits*, 12 × 12 in., oil on panel, 2013. Variety of warm and cool.

Laurel Daniel, *Clear Day Study*, 8 × 6 in., oil on panel, 2013. Example of a variety of edges.

Rule of Thirds: The circles are the "magic" spots where the center of interest should go.

My version of the rule of thirds: The circles are expanded to give you far greater leeway.

The Rule of Thirds

The rule of thirds is simple. If you draw lines on your canvas basically dividing it into thirds, horizontally and vertically—where those lines meet are the supposed "magic" spots. In theory, if you put your center of interest on or around one of these spots your composition will be magically improved!

If you think about it, this rule is consistent with the number one rule for variety and uneven distances. If you make the top-left spot your center of interest, your object(s) will be closer to the left and top of the canvas and further away from the right and bottom, giving you variety.

If we were to *expand* those four magic "spots" (see the circles expand?) into larger areas—so that we are basically avoiding (1) putting anything super important right in the middle, horizontally or vertically and (2) putting anything too close to the edge)—we get *my* version of the rule of thirds. I am happier thinking about my space this way, as I feel it gives me more leeway compositionally.

Another way to think about this is not *where* to put your center of interest, but rather, where *not* to. For example, it can be awkward when you put your center of interest in these spots:

- Right smack-dab in the middle of your canvas or panel
- An even distance from the edges horizontally or vertically
- Too close to the edge

More General Rules

Remember, rules are meant to be broken (I break them all the time). But it's always good to know the rules before you set about breaking them. Basically these rules will help you avoid the dreaded *awkward* composition.

Avoid Kissing Objects

Kissing is great, right? But the idea is that in paintings, barely "kissing" objects—ones that are touching but not overlapping—are awkward. Now, this is a rule I love to break anyway, but only if it feels right. If it looks awkward, I'll either move objects apart or overlap them. In the first example at right, not only is the cup kissing the vase (which doesn't bother me too much), but the tomato is *visually* touching the vase on the other side. In other words, even though they aren't *actually* touching, they *look* like they are because of our perspective. This is far more awkward in my opinion than actual kissing and should be avoided.

Awkward: An example of two kinds of kissing. Less awkward: No more kissing.

In the second example, both the cup and tomato are moved further away from the vase (different distances), and the plate and spoon are added for more variety. The composition could still use more work, but we've solved some basic problems.

Don't Kiss the Edge of the Canvas

This is a rule I don't break, because I've never seen it look right. Basically you don't want any object or line just barely touching the edge of your canvas/board. Either move them off the edge (crop them) or in from the edge a quarter of an inch or so.

Awkward: Two examples of objects kissing the edge of the canvas. Less awkward: No more kissing.

In this first example (middle right), the left edge of the plate is touching the edge of the picture as well as the top edge of the cup. In the second example I fixed both, by moving the plate away from the edge and cropping the top of the cup.

Avoid Rows of Objects

When done purposefully, I think rows of objects can work. But most of the time they just look awkward. Try a zigzag instead, with uneven spacing, or make a little pile or crop some of your objects.

Here's an example (bottom right) of a composition with an awkward row of tomatoes that are just about parallel to the row that the bowl and cup make. When two things make a row, it's unavoidable, but when three things make a row, it can be weird. In the second photo I've created

Awkward: Tomatoes too much in a row. Less awkward: Tomatoes spaced less evenly.

Awkward: Example of objects being cropped awkwardly at the corners. Less awkward: Changing the composition alleviates the awkward corner crops.

Awkward: Example of unfortunate tangents—objects touching other objects in unfortunate ways. Less awkward: Respacing the apples eliminates the unfortunate tangents.

a more dynamic composition by spacing the tomatoes unevenly and cropping one of them. I generally try not to crop objects in half, so I would probably still work on this one, but it's getting better.

Don't Make Lines or Other Objects Go Directly out the Corner

I've seen this work a few times, but mostly not. In the first example (far left), not only is the spoon going directly out the bottom-right corner, but the top-left tomato is also being cropped so that the distances along each corner are the same.

In the second example I moved the spoon into the cup for better positioning and recropped the tomatoes so no one gets chopped in a weird way. I see now that three of them are in a funny sort of row. This is a great example of how solving one problem often creates another one. And I did it on purpose. Yeah.

Avoid Unfortunate Tangents

This is basically when things line up in awkward ways. I see this happen a lot in my workshops and when I ask my students about it, they usually say something like, "I didn't plan it that way, it's just that things *grew* in the drawing phase and now it looks awkward." If this happens to you, reassess your composition after you draw it and be willing to redraw if things have shifted in awkward ways.

In the first example at left, the edges of two of the apples line up with the edges of the paper. The two apples on the left also form a funny kind of line with the bowl that I'm not crazy about. In the second image, the apples are respaced so that nothing is just touching the edge of the paper, and the line of apple-apple-bowl on the left is broken up by a light space near the top.

Fixing Often Means Breaking

As just mentioned, whenever I fix one of these "problems" in my composition, I often end up creating a whole new, *different* problem. And that's the way it goes. It's not easy to create interesting compositions with no awkwardness or unresolved parts. The more you can accept that, and accept that each composition will take time and work, the more you will be able to enjoy the process of creating.

Don't Ever Use the Line "But It Was Really Like That"

If there is something awkward (like a bad spot on the apple, or a weird curve, etc.), change it if you can (turn the apple around) or paint it out. Nobody cares if it was *really* like that or not, and you probably won't be there to explain it anyway. For example, I bought these cherries yesterday (at right) but they've already got little weird spots on them, so I'll either have to ignore them and hope I can get the highlights to look right or go and buy some more nice ones.

The Myth of Odds

Most of us have been told at some point that it's better to compose with an odd number of objects than an even number. I completely disagree. I think it's only *harder* to compose with even numbers, but certainly not impossible or *bad*.

Now Forget the Rules

Now that you have all these rules safely in your head, forget them! Seriously. Remember to start with your instinct only. If you bought some cherries this morning, start playing around with background colors. What grabs you? Pick out a couple of plates and a bowl, or a fork or a pig or a shoe to go with them. Get crazy!

If your subjects have weird spots on them, turn them so you see the good side, or get some new ones. Don't paint them that way anyway and then say, "But it was really like that!"

n your subjects. Try out different bulbs. Or put them by
use natural light. Start playing with your props. Play!
k. Don't limit yourself in *any* way. Use the craziest colors
silly. Stack things. Paint your own background fabric
fun!). Have fun and give yourself lots of time for this part.

inder

important to look at your setup through a viewfinder
ou settle on anything. Try different sizes and proportions of
ll your arrangement make a better big painting? Does it
tical, horizontal, or square?

ng Else

aren't working today, get something else. Maybe you've got
es in the kitchen that are just the right size for what you've
got going.

drawers of background paper and
fabric to create my compositions.

Folds in fabric are hard to paint, and
if your entire background is folds, the
resulting painting (unless the folds
are *perfect*) may be confusing to
the viewer. I find it helpful to work
more often with simple planes, and
maybe drape a little fabric that goes
through the composition, like this.
It is easier and generally ends up
making more sense to the viewer.

Cut It Up

If you bought some nice oranges at the market and you're playing around
with them but dang if they're not all the same size, consider cutting them
up! Suddenly you've got a lot more variety. Also, there are a lot of ways to
cut up an orange. I'm just sayin'.

Don't Be Ambiguous with Drapery

If you drape your backdrop into a corner and then crop in on your subject,
not only are you setting yourself up for a really tough painting (folds are
hard to paint!) but if you don't get it exactly right, you risk confusing your
viewer. My advice is to mostly work with flat planes, especially until you
get the hang of folds. If you must have drapery, I recommend showing
some edges so the viewer understands that it is fabric.

Try your composition out with different viewfinders of various dimensions. Would it look
better square, 5 by 7 inch, 30 by 40 inch, and so on? Is the background too boring? Do you
need some homemade polka dots? Would the orange look better cut up?

Don't Get Stuck

Don't get stuck thinking you *have* to paint that special (insert special, meaningful thing here)—or a totally awesome, funny, or meaningful concept—at the expense of a really bad painting. Maybe that special thing or concept, while very meaningful, is too complicated, busy, or ugly. Or maybe you should just save it for another day.

Give Yourself a Break

Don't feel as if you've failed when you've spent an hour playing with your props and still haven't come up with a composition! I know—I've beaten myself up unnecessarily many times. Sometimes it takes me a few hours to get excited about a composition.

Get Excited!

Or rather, wait until you're excited to paint something. If you're not excited, but you paint it anyway, the viewer probably isn't going to be excited enough to buy it.

Almost Excited

And when you're *almost* excited, but something little just isn't working, *then* consult the rules. If, on the other hand, you like what you've got, but you notice you're breaking a rule, perhaps just . . . break it! Most important, have fun!

Exercise—Four in Four

Choose a simple cup (or other object from around the house) and four pieces of paper that are all different colors but preferably go well together. Now create and paint four different compositions using just these four objects. Try different vantage points and lighting from different angles. Don't paint until you're excited about each composition.

1

2

3

Practical Application: Breaking Rules!

Now I'll show you an example of a painting, step by step, that breaks several rules. There will be kissing, touching, drinking . . . oh wait, none of that . . . uhhh, objects in a row, and so on. I did it all on purpose, and it's up to you to decide if it works or not.

In the reference photo you can see right away that the plate is centered at the top of the painting, breaking my first rule. If you count the total number of objects you will find that I have an even rather than an odd number—second rule broken. The middle apple is kissing the fork, though I did try to minimize that in the painting. The fork and spoon are perfectly parallel and in a row with all my other objects, breaking yet another rule. I call the finished painting, *Orderly Apples*.

I showed the drawing step by step in chapter 6, so now I'll jump right in with the painting part.

1. In the first image (middle left) you can see I start with the apples, blocking in the light and shadow sides, making sure to keep it loose by going past the edges (more about this in chapter 8).

2. Next, I block in the darks of the silverware. Keep in mind—most metal has lots of darks in it and just a little bit of light. If you don't make the darks dark enough, the highlights don't have that *ping!* effect! I also work here on the reflected light on the apples (that is, the light reflecting back on the apples from their surroundings) and on the darkest parts of the apple—the *form* shadows (that is, the shadows *on* the apples).

3. Then, I put some of the slightly lighter bits (also reflected light) on the silverware and start working on the shadows cast by the apples (called the *cast* shadows). Notice the little white marks on the left side of the middle apple? I need to re-*find* that edge, so I used my rubber tool to wipe away some paint.

1. Reference photo for *Orderly Apples* (painted from life). **2.** Step 1: First I block in the light and shadow areas of the apples, keeping my edges loose. **3.** Step 2: I block in the darks in the silverware, reflected light on the apples, and the darkest parts of the apple—the form shadows.

Apple demo, step 3: Here I work more on the silverware and start adding the cast shadows.

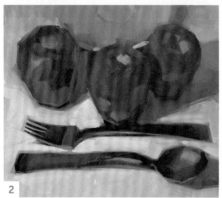

1. Step 4: Next I add the plate and its shadow, and start carving out the edges of all my objects with the background color. **2.** Step 5: Next I paint the remainder of the background, paying special attention to the edges.

4. The next step (at left) is to establish the plate above the apples, and its shadow, and then start filling in the background, paying special attention to edges. A little tip for painting a fork is to ignore the tines to begin with and paint it as one solid object. When you get ready to paint in the negative spaces around the tines, start with the middle one first (there are usually three spaces), and then paint the other two, one on either side. This makes it a lot easier to get the spacing right.

5. Next I fill in the rest of the background and make adjustments here and there. I am careful not to go back into the apples or silverware much and risk getting them muddy and looking fussed over. I am also careful with all the edges, making sure to leave some sharper and some softer. Specifically, edges of shadows tend to be softer.

6. My last step is to add what my friend Jennifer calls the "bling." I add highlights to the apples, plate, and silverware; I add stems to the apples, make some other minor adjustments to the background, and sign my initials with my rubber brush on the bottom-right corner. I'm done with my rule-breaking painting, and I'm happy with how it turned out.

Step 6: The last step is to add the bling and sign it. I'm done! *Orderly Apples*, 6 × 6 in., oil on panel, 2013.

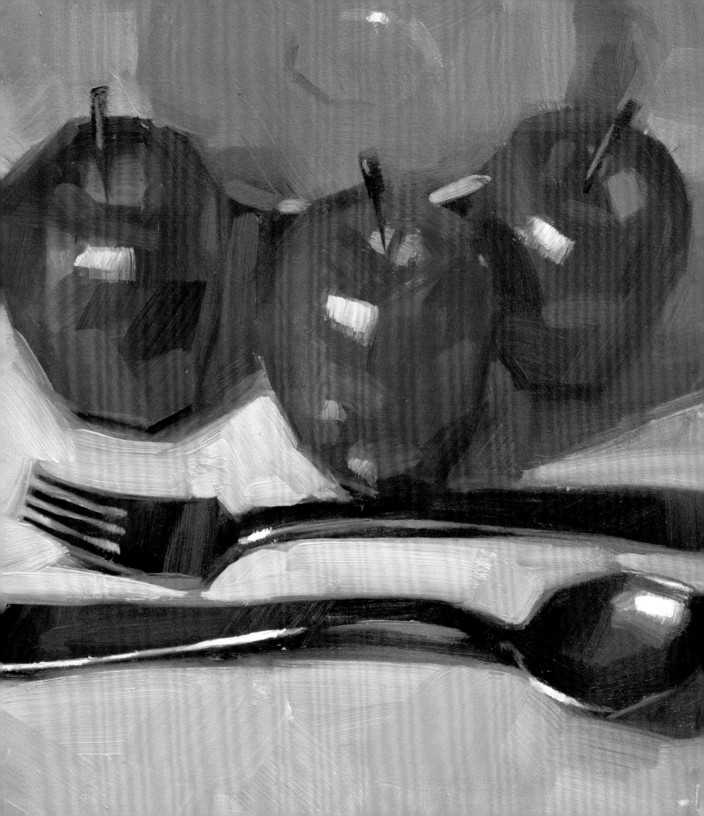

8

Staying Fresh and Loose with Oil

As the title implies, this chapter is going to pertain pretty much only to oil painting, though you may get something out of it even if you use something different. Or you might just get inspired enough to try oil!

Oil is my preferred medium, and what I talk about here diverges somewhat from most common approaches to painting with it. My approach will give you cleaner, fresher colors and looser, more painterly edges. If that's not what you're looking for, then feel free to skip this chapter.

Cowabunga, 6 × 6 in., oil on panel, 2010.

Alla Prima Painting

Doing a small painting all in one go (sitting) is called "alla prima painting" or "wet into wet." This requires a different approach than a painting done over a longer period that dries between stages.

With alla prima painting, because your paint is wet, every stroke you put down is going to mix somewhat with what is underneath and around it (how much it mixes depends on how loaded your brush is and how thick the paint under and around it is). Because of this, you really have to consider what should be painted first, second, and so on. I prefer to think of it like a chess game: I must plan out my moves ahead of time so (hopefully) I don't get beaten. Often when artists make *too many* moves, they get mud as a result. In this way, painting can also be compared to golf—the fewer strokes the better.

Through trial and error, I have come up with a general approach that works well for me and allows me to keep my colors fresher and my edges looser and more interesting (in my opinion). My approach is different from the age-old dark-to-light method but perhaps requires a bit more thinking. First, though, I'd like to explore the idea of a ground (underpainting).

Putting down a Ground

What is a ground? It's a thin layer of paint (thinned with OMS) applied before anything else, then wiped evenly with a paper towel so it's not too wet (see image 2). If you prefer, you can apply a color with acrylic paint the night before so your ground is entirely dry, but I prefer it a little wet.

Is a ground necessary? No, it is completely optional, but I like to use them for three reasons:

- Oh, let's just start by covering up all that intimidating white, shall we?!

- It makes my surface a little wet, which I like because it allows my paint strokes to go on better—this is why I put down the ground right before I paint.

- I love the little bits of ground color poking through the finished painting.

How do I choose the color of my ground? Well, first of all, there is no *right* color. I have my own personal method, which you can experiment with, or you can find your own. Some people put down the same color every time. I like to ask myself the following series of questions:

1

2

3

1. Cathleen Rehfeld, *Silly Chickens*, 6 × 6 in., oil on panel, 2013. Cathleen likes to prep her panels with black gesso ahead of time and then do her painting in oil. **2.** Me, wiping the wet ground (of burnt umber) with a paper towel. **3.** *Organized Breakfast*, 6 × 6 in., oil on panel, 2010. Example of a blue-dominant painting, with an orange ground underneath (orange is the complement of blue).

1. *Escape from Alcatraz*, 5 × 7 in., oil on panel, 2012. Even though the dominant color in this painting is orange, I didn't want to use blue for the ground and risk muddying the flowers, so I used burnt umber instead, a fairly neutral color.

2. Warning! Don't use a strongly colored ground on a painting with a lot of white in it. I used red here and didn't realize until the next day that the entire painting was tinted pink!

- **What is my dominant color?** The "dominant" color is the one that takes up the most *room* in the painting. So if you took the final image and cut it up into one hundred little squares, then you put all the blues in one pile, the reds in another pile, and so on, which color would make the biggest pile? That color is dominant. My ground color then is often the *complement* of that dominant color (see image 3 on page 119).

- **Is anything important in my painting going to be muddied by the ground I chose from question one?** For example—I wouldn't want a green ground if my star is a bright red apple. Remember this is alla prima painting, so everything underneath is going to affect the paint I put on top. If muddying will occur, is there a different color I could use (see image 1 at left)?

- **Is there a different color I want to see poking through the finished painting?** Instinct plays a big role in this one (see opposite image).

Some Very Important *Ground* Rules

I have found that some colors don't work well as grounds, and others work perfectly for certain situations. Here are a few ground rules I like to follow:

- Don't ever use white in your ground—white will mix with everything you put over it, making your entire painting look chalky.

- Don't ever use phthalo in your ground—it's a very strong color and tends to mix with everything and tint your painting turquoise.

- If your subject has a lot of white in it, I recommend using burnt umber or a different neutral color (or mix of blue, red and yellow) for your ground (see image 2 at left for a bad example).

- If you aren't sure what your ground color should be, experiment with several. You will get a feeling as time passes about what works and what doesn't. You can also try putting down your ground with acrylic paint the night before—then it won't mix with what goes on top.

Green Squash, 6 × 6 in., oil on panel, 2007. This is an example of an early daily painting of mine where the dominant color was a blue/purple and my subject was green. I decided I wanted a warmer color poking through so I chose alizarin crimson for my ground.

I've numbered the tomato from 1 to 6 to show the order of steps I would take in painting this tomato, from most to least vulnerable.

Two examples of a yellow flower—one with the flower painted first and the other with the background first. Notice how the top flower is carved out by the background. A little of the yellow gets into the gray, but I feel like because of it, the flower "lives" there better. The second example gets gloppy in order to compensate for the gray that inevitably gets mixed into the yellow.

Planning Your Moves

After drawing your composition, which we covered in chapter 6, it's time to start painting. But what to paint first?!? Many amateur artists want to avoid the tough stuff, so they paint the background first. Many teachers will suggest you paint the darks first and make your way to the lights. My method is different, a little more complicated, and certainly not for everyone. Honestly I think this is one of the best things that came out of my *un*-university experience.

My method is to start with *more* vulnerable areas and work my way toward areas that are *less* vulnerable. *What is more vulnerable?*—areas of color (usually more than one stroke) that would be hard to paint and make look good if you painted other areas first. This probably sounds a bit vague, but bear with me.

There are two things I have found that make an area *more* vulnerable:

- The area is an "island" (surrounded by an "ocean").
- The area of color is very saturated (and usually within an island), and you want to be careful to keep it that way.

So what does that mean? Let's take the tomato at left, for example. First of all, the *entire* tomato is an island, so I would paint it before the turquoise background. *Within* the tomato, I would paint the most saturated reds first (1), the part that happens to be in the light. To mix the form shadow (the shadow *on* the tomato), I've got to mix darker, grayer reds, which (if you remember from chapter 5) requires all three primaries. If I painted the shadow side first, I would risk getting that dark red-gray into the saturated color on the light side. Once the nice reds were in, I would be very careful not to go back into them. Next I would paint the transition from light to shadow and then the form shadow (2). Then the reflected light (coming from the turquoise) (3), the cast shadow (cast from the tomato) (4), and the "ocean" (turquoise) (5). And last, the bling: the highlights and stem (6).

What is least vulnerable? Very small areas that can go *on top of* other paint are the least vulnerable, for example, highlights, thin stems, thin rims of cups, small polka dots, and so on.

It is very important with this approach that you *not* paint back into vulnerable areas, unless you do it very carefully and mindfully, and with the correct color on your brush. Even when putting on the least vulnerable bits, like the highlights, you shouldn't fuss with your paint, but rather put one (or more if required) mark on confidently. If it doesn't turn out right, I suggest using the rubber brush to remove the stroke, repaint just what was underneath, and try again.

Now let's say you are painting a bright yellow flower (opposite page) with a gray background. If you paint the background *first*, it will be incredibly difficult to put the yellow in without contaminating and muddying it with gray, because it mixes very easily at the edges. If you do manage it, the edges are going to tend to be fussy and cutout looking, and your yellow will get thicker and gloppier.

If instead you paint the flower first and then the background, your yellow will remain saturated (as long as you don't go back and mess with it), and you have a chance to make much more interesting edges, in my opinion. Your flower will also "live" better in its environment, as little bits of yellow will get mixed out into the background, making it sort of "glow."

In more complicated scenes, you generally have islands within islands within islands, and so on. I have found it is best to paint them in order, from the inside out. This watermelon end in a bowl (above right) is a perfect example. I started with the area near 1 (the juice and the area around it), next 2 (the flat area around 1), and so on, putting 9 in last.

Sometimes your scene is a complicated puzzle of shapes, and there are some clear islands and oceans but also other areas that aren't so clear. Sometimes there *is* no best way, and you have to choose something and go for it. If one order doesn't work, wipe it off and try another.

Often it is good, especially if you are new to painting, to make "notes" of color when you need to see the relationships sooner. For example, if you need to relate the color or value of your subject to your background, mix the background color and put one stroke in the background, away from any edges.

Watermelon Soup, 6 × 6 in., oil on panel, 2011. This is an example of a composition with islands within islands within islands, which I painted in order, from 1 to 9.

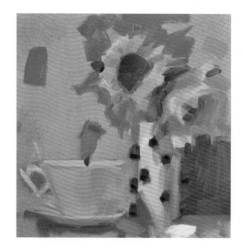

Example of "color notes" in areas where I needed to see a relationship between colors before moving on to other things.

1. Tomato demo, reference photo (painted from life). **2.** Step 1: First, I draw my composition. **3.** Step 2: Next (after wiping off most of the paint from the drawing), I block in the tomatoes, keeping it loose.

Edges

In addition to painting from the inside out (island to ocean), I recommend painting past the edges (i.e., the lines you have drawn in the first place) and then reshaping with the color on the other side of the edge.

This technique does several things for you:

- You make looser, more painterly marks.
- Your finished painting appears looser.
- Your subjects don't look "cut out."
- Your subjects "live" in their environment.
- Your objects appear more "real."

Here's an example, from start to finish, of an entire painting of tomatoes and a plate (to see videos of a few other demos go to my blog: carolmarine.blogspot.com and click on "Art Tutorials"):

1. First I draw my composition with burnt umber (see image 2), on a ground of the same color. You can see the drawing because the ground is a thinned version, so the drawn lines appear darker. I am careful to add just a tiny bit of OMS to my paint for drawing—if I add too much, it will all be wiped off in the next step.

2. Next I lightly wipe off most of the paint from the drawing so I can still see a "ghost" of it (see image 3), but the paint isn't so thick it interferes with the strokes of paint that come after the drawing. Then I start with the tomatoes, my first "islands," painting the saturated sides first and then the shadow sides. I make sure to keep the edges of the tomatoes loose—going past the edges with my paint.

3. Then I paint the plate (see image 1 on page 126), which is butted up against the tomatoes. I don't go past the edges as much here, since I know the next step will be the shadow of the plate, and if I have too much white there it will lighten it too much. I also put in a few marks on the tomatoes to indicate the reflected light.

4. I start in on the cast shadows, of the plate and the tomatoes (see image 1 on page 126). All the shadow colors are "gray," in other words, a mix of red, blue, yellow, and maybe white.

Tomato demo, step 3: Next I work on the plate.

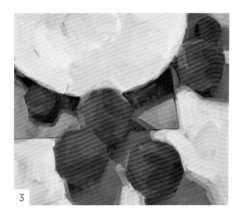

1. Step 4: Next I block in the cast shadows of the tomatoes and plate.
2. Step 5: Then I finish the shadows, complete with "umbra" (darkest part of the shadow) and "penumbra" (fuzzy edge of the shadow).
3. Step 6: Next I fill in the ocean, paying special attention to the edges.

5. Often the part of the shadow *right* next to the object that's casting it is darker than the rest of the shadow (see image 2). I call this the "umbra," and it is important to get it in if you see it, because objects can sometimes *float* (not appear to touch the surface below them) if you miss it. Because shadow edges are often soft or fuzzy, I like to mix an intermediate color and put that on the edges of the shadow shapes, before I start painting the ocean. I call this the "penumbra."

6. Next comes the "ocean" (see image 3). Here I am reshaping all my edges, being very careful not to go back into my islands and muddy them with my ocean colors. I am also careful with my edges, trying to make them interesting and varied. I think about each stroke before I put it down.

There are all sorts of edges you can make with paint and all sorts of techniques for making them. My motto for painting in general, but especially for edges, is—how can I do this in as few strokes and with as little fussing as possible?

I would argue that it's fairly easy to make hard edges, and most beginning artists make them exclusively whether they mean to or not. Soft or "lost" edges require a bit more finesse, especially if you don't want them to look over-blended.

Soft edges are often appropriate where the two colors on either side of an edge are similar in value. One place this tends to happen is where a form shadow meets a cast shadow. To illustrate this, look at the soft edges on the shadow sides of the cups on page 129. Note the harder edge where the dark spoon meets the light part of the cup.

Another reason to employ softer edges is that it helps hide mistakes in form and proportion. I'm not kidding! If every edge is hard, any mistakes will stand out like a sore thumb.

7. The last step is the "bling" (opposite). I add the stems to the tomatoes, careful to indicate where they cast shadows on the tomatoes, and then the highlights. My students often ask me if I ever put the highlights in before the end, and the answer is, "Sometimes, but it's much less satisfying if I get to the end and the highlights are already there!" I love being able to pull it all together right at the end. The highlights are almost never straight white. I always consider the color of the object *and* the color of the light.

All Off, 6 × 6 in., oil on panel, 2013. Highlights and stems go on last.

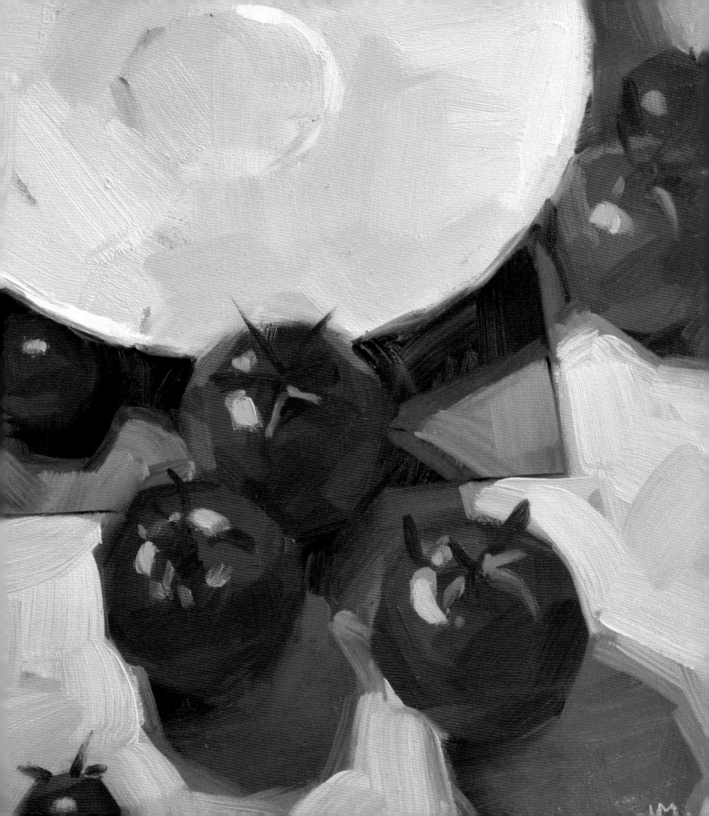

Playing-with-edges exercise: Here is my example for this exercise. I played with my paint and the edges, with no regard for what it would look like in the end. Yours does not need to look like this at all. Simply play.

Exercise—Playing with Edges

Take out a bit of canvas or a panel and experiment with edges. Make an island with one color, and a small ocean around it with another. Repeat. Try making hard edges, soft edges, and gradients, without fussing too much. Pay attention to how much paint you're using, what direction you're swiping, how hard you push down on the brush, what angle you're holding the brush, and so on. Play with your paint. See what it does.

To Keep in Mind While You're Painting

Here are a few general things I like to ask myself, or just generally try to keep in mind when I am painting:

- **Ask yourself about your subject.** Where is the darkest value? Lightest value? Most saturated color? Be sure to compare everything else to those extremes.

- **Remember to squint and step back often.** You can't hear this too many times!

- **When mixing colors that will be near each other on your painting, consider mixing them close on your palette.** This allows you to see color and value relationships before you commit paint to the canvas.

- **Consider sculpting your subject, with paint strokes.**

- **Don't necessarily fill up one big area with one color, even if it is one color.** You can make it much more interesting by mixing different versions of that color and laying them side by side—as long as they are all the *correct value*.

- I absolutely *do not* **recommend holding your brush or palette knife up to your subject to see if you got the color right!** This is bad for so many reasons. For starters, the light on your setup is most likely different from what is on your panel and palette, and the color and value you see on your brush will differ depending on the angle of your brush and how the light is hitting it. Also, your goal is to have your colors relate on the panel—your goal is *not* to make them exact (not that holding your brush up to your subject will net you exactness).

- **If your painting isn't working out, I think it is almost always better to wipe it off (with a paper towel dipped in OMS) rather than keep it around with the idea of "fixing" it later.** This is hard to do but freeing! Most of the time what doesn't work is something fundamental and not easy to fix. And when you keep something like that sitting around the studio, it just makes you feel bad every time you look at it. Better to wipe it now and save yourself that grief . . . and the panel, and make something better with the next one. I have never, ever regretted wiping a painting, but I regret it when I don't wipe a bad one!

- **There is no right way to paint.** Each teacher can only tell you what works for him or her—take it all with a grain of salt. Question everything (even me). Experiment constantly.

Many Shades of White, 6 × 6 in., oil on panel, 2013. Notice the variety of hard and soft edges in this painting, specifically where indicated (mentioned on page 126).

Squinting and Stepping Back

I know I've already mentioned this, but it is incredibly important to squint at your subject and to step back often. It is easy to get too close to your subject and miss the big picture. It is also very easy to catch the detail-itis disease! The main symptom is fussiness, which leads you in the exact *opposite* direction from loose.

Practical Application: Apple—Common Mistakes

I thought it might be helpful to see an example (see left and opposite) of a beginner's apple (done by me but illustrating all the common mistakes I see from my students) next to an apple I might paint. Well, I *did* paint it, but you get the idea. I'll describe all the problems I see in the first apple, and you can see how I've solved these in the second one.

First of all the shape of the "bad" apple is funky. The stem "hole" is too far down on the apple, which I see all the time, and the bottom of the apple is completely flat. The left side of the apple goes straight into the shadow with no break or indent (unfortunate tangent), which makes for an awkward composition. The solution to all of these problems is better observation. These mistakes are made when the artist listens too closely to what the brain is saying about the apple, rather than what they are really seeing.

All the edges of the "bad" apple and shadow are hard. The whole thing looks like a cutout. Most importantly, the edge between the form and cast shadow, and the edges of the cast shadow, should all be softer, as I've done in the second example.

The cast shadow is purple, uniform, and too dark. I see this a lot from students who have previously painted landscapes. They have in mind that shadows should be purple, because shadows often are when outside. And we all think of shadows as dark. In the second example the shadow isn't just a one color or value. It is darkest next to the apple and gets lighter as it moves further away. The colors are also different, and match more closely what I saw.

The highlights on the "bad" apple are too big, straight white, and too uniform. Another common mistake with highlights is to fuss with them too much until they disappear right into the object. I ask this a lot: "Why

My approximation of a beginner's apple, with a lot of common mistakes.

A more advanced apple, with all the problems "fixed."

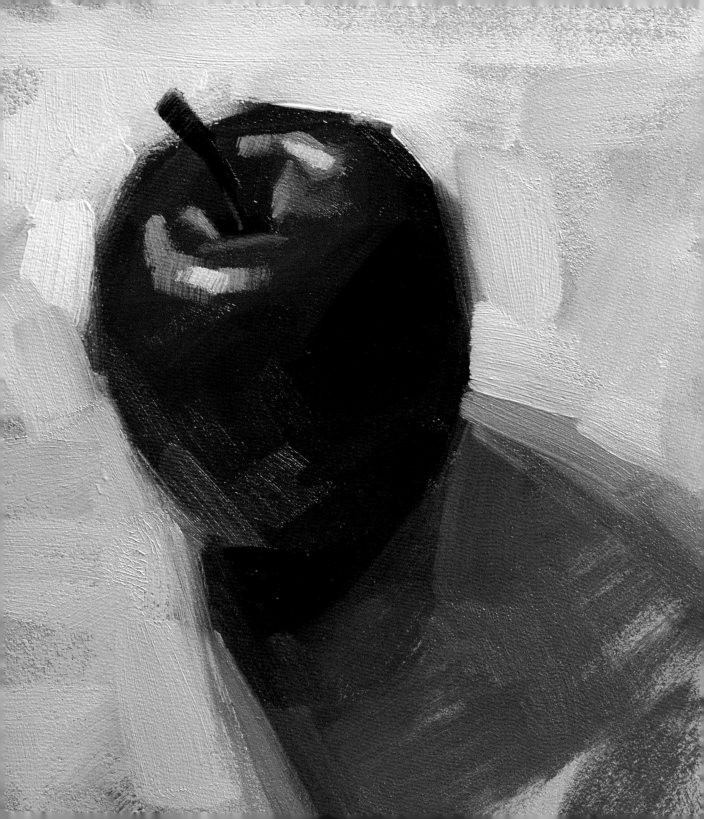

Exercise—
Ten-Minute Apples

Get a timer and divide your painting surface (panel, canvas, paper, etc.) into eight or so small squares (or rectangles). They should be smallish—two to three inches square or thereabouts—they don't have to be perfect. Now retrieve your apple and light it dramatically. Set your timer for ten minutes. Paint your apple in the first square. When the timer goes off—stop! I mean it. Repeat in each square until you're done. You can rotate your apple and/or change the light for each new square. Whatever you do, don't go back and fix old ones or you won't see any progress.

The point of this exercise is to get a feel for your apple in terms of brush strokes. Make sure you squint and simplify. Don't get bogged down by the details or you'll never finish. Try to think of it not as an apple, but rather as just shapes and colors and values. Paint what you see—not what you think you see. If you find yourself doing the same thing every time—experiment! You won't learn unless you try something different. Expect the first one to be bad—you are still getting a feel for just how long ten minutes is. They will only get better. If they don't, try again tomorrow.

didn't you put in the highlights?" Answer: "I did—can't you see them?" No. The application of highlights should be confident and well placed the first time. If you get it wrong, I recommend removing it, repainting the bit underneath, and trying again. The color of the highlight should take the color of the object into consideration, as well as the color of the light hitting it. Sometimes, if the highlight is fairly soft, I put down several strokes, with each subsequent stroke getting a little lighter and smaller, as I did in the second example.

The brush strokes around the "bad" apple are all going in the same direction (around). It can really help to have a variety of strokes (size, direction, slight color differences). Also the value of the "ocean" doesn't change at all, which lends the whole thing a very *flat* appearance. Notice how in the second example the ocean is lighter at the top and darker at the bottom.

The form shadow on the "bad" apple is not dark or gray enough; I made it by adding alizarin crimson to cadmium red. In the second example, I darkened my cadmium red using ultramarine blue and maybe some cadmium yellow light.

Lastly, the reflected light (that little pink spot on the bottom-left part of the apple) is too light and too saturated. Reflected light is subtle but important. Not often will you get a comment about your painting like, "Wow, great reflected light!" But viewers will know if it's wrong.

This chapter is all about keeping your *oils* fresh and loose, but I wanted to show work from a couple of great artists who paint loose with acrylic!

Top Six Mistakes Students Make

To sidestep mistakes, avoid these behaviors:

1. **Being cheap!** Students often don't put down or use enough paint. Or they mix a lot of the wrong color (often with a palette knife) and put it down anyway because they don't want to ditch a whole big pile of paint. They also tend to buy cheap materials, which only leads to frustration!

2. **Being lazy!** Students often don't clean their brushes often or well enough, and the wrong paint ends up graying down what should be a saturated color, or white lightens or chalks down what should be a dark or saturated color.

3. **Being emotionally attached!** Students often want so much for each painting to be a masterpiece, they can't let go, move on, and learn from mistakes.

4. **Having tunnel vision!** Students tend to compare values, colors, proportion, and so on in only one small area at a time instead of looking at everything in the whole painting. Specifically, this tendency to have tunnel vision when it comes to value is what I help the most with at workshops.

5. **Having detail-itis!** Students often get so involved with every little detail that they fuss the painting to death and miss the big picture.

6. **Believing that lines are God!** Students tend never to stray from the lines of the drawing, which creates hard, tight lines, no looseness, and no life!

David Lloyd, *Tan Room with Flowers*, 5 × 7 in., acrylic on watercolor/illustration board, 2012.

Patti Mollica, *Opposing Forces in NYC*, 14 × 14 in., acrylic on panel, 2013.

Fighting Artist's Block

Blocks: You hear about them. You know everyone gets them. You prepare yourself. But when it actually happens to *you*, all you can think is, "I've lost it and I'll never get it back!"

Right?! It's a horrible, awful, terrible, depressing place to be. And it happens to me on a regular basis. But do I ever accept the regularity and realize all is not in fact lost each and *every* time? No; I wallow in despair, admit nothing, and take it out on my husband. Healthy? Not in the least.

In 2012 I had a particularly terrible block. It was so bad that I actually announced to my (extended) family that I was done with painting for good and would be finding a new career going forward. And I was serious. Somehow they all kept straight faces and rolled with it.

The Dark Place Called "I Never Want to Paint Again!"

Daily painting for me was life changing. I went from doing large, boring paintings and being depressed all the time, to doing small, fun paintings, selling them online, and actually making a living. I woke up every morning completely inspired. I felt I had a never-emptying fount of small-painting ideas. People would ask me, "Aren't you tired of painting apples?" And I honestly wasn't.

But after a few years, I started having small periods of dissatisfaction and minor blocks. Usually it helped to try a new subject for a while or take a day off. I always seemed to get my mojo back, so I didn't worry. And I had this fabulous job, so how could I possibly complain?!

Parked in Green, 5 × 7 in., oil on panel, 2013.

Breezy Windows, 8 × 12 in., oil on panel.

But those small periods got longer, and the blocks became bigger. And all the time I told myself, "Just work through it!" So I went into my studio even when I didn't feel like it, and painted even when I was completely uninspired. The result? Sure, I painted, but I became less and less satisfied with the process and with my paintings.

Then in December of 2012 I realized I needed to get ahead with my paintings because I had a lot of traveling coming up but still wanted to post to my blog while I was gone. I had five days left, so I decided to push myself and do as many paintings as I could. I had done this *many* times before, but this time, three days into it, something broke. My creative well was finally completely dry, and I was scraping the bottom so badly it hurt. I cried for days. My husband was very nice about it, even when I wasn't nice to him (thank you, David!). I had no inspiration, no ideas, and no desire to paint *anything*! Just the thought of a paintbrush made me wince.

Fortunately, traveling for the holidays meant an enforced break from painting. It was on that trip that I announced painting for me was a thing of the past, and I started to brainstorm other career opportunities. I could learn to cut hair, make pottery, . . . I considered becoming a checker at a grocery store. I tried each thing out in my mind, but nothing seemed like a fit. In the back of my mind I knew I would get bored with those things too (and probably quickly).

About this same time my friend Leslie Saeta asked me to cohost her radio show (*Artists Helping Artists* [AHA]) for a day, and I said, "Sorry, it's such a bad time—I don't know if I'll ever paint again," thinking she would never understand. She said, "Oh, so you're visiting the dark placed called 'I'll never paint again.'" What? Other people feel this way too sometimes? This place is so common it has a name?! Suddenly I didn't feel so alone. I had friends in the dark place with me, even though I couldn't see them.

After about two weeks of not painting, that part of my brain that gets ideas started to tingle. I had nothing solid—no images—but I felt that at some point I could possibly, maybe become excited about something visual again.

When I got home from my trip, I started getting a few ideas—solid ones even. Not all of them were about painting, unfortunately. I had some fabulous ideas about quilting and purse design! The ones that *were* about painting were . . . different from what I'd done before, but they were ideas!

What I've Done Differently Since Then

I know I'll have more blocks in the future—and some that may last longer than a few weeks. Just acknowledging that was my first step. Obviously I would prefer to avoid that pain, but I know it will happen—there's no getting around it. My good friend Bren sent me these words to live by, "Honor the Ebb." This implies there is a natural ebb and flow to *everything*, and we must honor it rather than desiring only the flow and resisting or rejecting the ebb. My future goal is to someday even *enjoy* the ebb.

One giant part of what I've changed is to paint only when I feel inspired. This has been particularly difficult for me (and still presents a challenge sometimes) as I feel it's something a spoiled princess would strive for, and I was raised with a particularly strong work ethic. But with a creative profession, I feel it's important to balance the chase for the next idea with a resting period in which I allow the idea to come. Looking back it seems that every time I pushed myself even when I wasn't into it, it eventually cost me, even when I came up with something decent as a result.

Another part of my plan was to branch out. Since 2012 I've tried several new media, bought new materials, taken workshops, painted new subject matter, and generally experimented more. I will continue to do this until I run out of new things to try (which I hope will never happen!).

When you build up an audience and people are *counting* on you to post, *and* it has become your livelihood, it can be a tough decision to scale back. But that was another part of my plan. If I don't feel like painting and therefore have no paintings to post, I don't post.

Different Needs, Different Times

Caring for a creative animal is a difficult task and all the more so when it is yourself you are caring for. Sometimes we need a push, sometimes a break, sometimes a cry, sometimes a little tough love, and sometimes a good hug from a good friend. I am the absolute worst at figuring out what I need and when. But hopefully I will continue to get better.

After my big block, I asked some of my friends and fellow artists to share a few of their own stories and tips. Amazingly they all had wildly different things to say, and their ideas have helped me tremendously. I hope they do for you as well. The rest of the chapter is completely in their words.

Sardines and One Tomato, 6 × 6 in., oil on panel, 2013.

Liz Wiltzen, *Passing Through Queens*, 12 × 24 in., oil on linen, 2012.

Liz Wiltzen

What Exactly Is Artist's Block?

Everyone has heard of artist's block, and most of us have had direct experience with it. I have come to believe that it is not a problem to be dreaded; it's simply a natural part of the painting experience to be honored and managed in an effective way.

I often hear other artists talk about their undying passion for painting, how it is all they can think of, and how they are at their happiest when they are in the studio. They describe how the whole rest of their life feels like it is pulling them away from what they really want to be doing—painting! Whenever I hear this, all I can think is, "Really? Really that's what it's like for you? Always?"

I can't relate to this on any level. I have wonderful, amazing moments of feeling like this, but whole weeks strung together? Not ever. If that's "normal," then I am a seriously blocked artist. For me painting is a roller coaster where the highs are when I feel inspired, motivated, engaged, and passionate, and the lows, which occur with equal frequency, are about avoidance, procrastination, and huge aversion to the problem solving-nature of the process and the angst of my vision frequently exceeding my grasp.

In my experience, artist's block is not a rare and sporadic thing, but a very real aspect of the choice to paint on a full-time basis—especially if your income depends on it. Perhaps this is not true for everyone, but certainly for a large number of us, it is.

Looking into the Eye of the Beast

An artist friend described it well when she said, "How do I know when I'm blocked? You can see the claw marks on the wall going into the studio."

In twenty-five years of painting, I have experienced two distinct types of "artist's block." In one, I go to the studio and procrastinate like mad until I finally duct-tape a brush to my hand and prop myself up in front of the easel, determined to get something done so that I can justify going home. The other is about completely checking out—simply not going in to the studio at all.

They have different sources but one strong underlying theme in common. In both cases what is most present is the discontent of "needing" to create something but feeling completely unengaged, unmotivated, and uninspired. The first type is pretty manageable; the second is not quite so simple.

Type 1—Short-Term Block

This can happen for many different reasons. We can be one or more of the following:

- Out of inspiration, having just used up a recent stash of good ideas

- Conflicted by loving different painting styles and not sure which one to pursue

- Frustrated by our paintings not reflecting what we intended for them (even when we're not sure what that is, we're clear it's better than what actually showed up on the canvas)

- Temporarily burned out from a big push and needing to refuel

- Distracted by a major life event

The great news about a short-term block is that there are several effective solutions. First of all, check in to see if you just need some downtime. Once

that's handled, here are some ways to get the creative fires roaring again:

- **Take a workshop.** Pick a painter whose work you really admire and go learn something from them. This is a no-fail way to spark new ideas and open up some intriguing avenues to explore.

- **Tackle some new subject matter.** I personally love this approach. If I have been painting landscapes, switching to portrait or still life or urban landscape always challenges me in a new way and gives me different elements to play with. Although at its most fundamental level, painting is about value, shape, color, and edges—shaking up your subject matter challenges you to find unique ways to apply these key principles.

- **Try on another medium.** If you're really ready to mix it up, a new medium can throw you into the deep end in the most engaging way.

- **Change your environment or perspective.** There are several ways to do this. You can go on a painting trip to a new locale. If you normally paint indoors, get outside. If you normally work from life, play with some photo reference, or vice versa. If you paint small, hoist a large canvas onto the easel and break out the big brushes. If you paint big, try to express yourself on a small canvas (and stick with the big brushes). Stepping out of your comfort zone will compel you to be present, focused, and paying attention—a surefire antidote to feeling stuck.

- **Explore an alternate creative outlet.** During a recent block, I ditched the paints and picked up my camera. I was intentionally *not* out to collect painting reference. I just decided to explore the world through a lens for its own sake. Different kinds of problems to solve, different impressions to discover, a different tool to express my creative vision. It was like hunting for treasure—a fun, liberating, and much needed break.

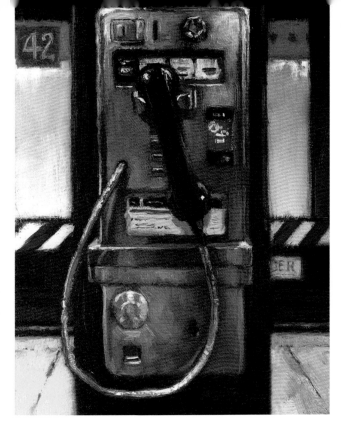

Liz Wiltzen, *Wired*, 8 × 6 in., oil on linen, 2013.

Type 2—Existential, Big-Picture Block

This beast is a lot bigger. In my case, it crept in insidiously over a long period of time as a result of ongoing commercial restraints and dictates. I think the straw that broke the camel's back was painting for three solo shows in one year. That experience wreaked complete havoc with the natural creative process as by necessity it was very time bound and demanded "successful" outcomes. I began to feel seriously pushed around by what "needed" to happen when I was in the studio and eventually found that I lost all interest in painting.

I love being that fed up because it frees you to make bold decisions. What everyone else wants or what you "should" be doing becomes irrelevant. All that matters is, "This is no longer working for me."

At that point I made one of the best decisions of my painting career; I gave myself permission to step completely away, to simply not paint again unless, and only if, I wanted to. It lasted for almost two years. I used that time to let some questions quietly simmer on the back burner. "Why do I paint?" "Am I in joy when I'm painting?" "If not, why keep doing it?" "What would life be like without it?" "Where does painting fit into my life if my ultimate goal is to feel peaceful, happy, and fulfilled?"

Eventually I started to feel my way back into the studio, but I decided, "At no time, for any reason, under any circumstance is it acceptable to have negative energy in my studio." I committed that if it showed up, I would send it packing, and if I couldn't do that, I would go home—forever if necessary. The good news is that giving myself permission to paint on my terms and committing to take charge of my headspace changed everything. I have claimed painting back in a way that was only possible by deciding to let it go unless it was joyful.

I love what Sigmund Freud said: "When inspiration does not come to me, I go halfway to meet it." Because there are still days when painting is work, and to get work done, it's necessary to get into the studio even when I don't feel like it. What's changed is how I handle that.

When I am challenged by a painting or not feeling focused, instead of beating myself up with crazy messages like, "I'm a hack, I'll never be any good, I don't have a clue what I'm doing, might as well give up now, I hate painting. . . ." I have learned to notice the voices, put my brush down, and ask myself, "What's here right now? No judgment. Just noticing." I give that some space and then ask, "What would I like there to be here, right now?" And then I choose.

Liz Wiltzen, *Night on the Town*, 9 × 12 in., oil on linen, 2013.

The most important thing has been to eliminate anything that makes outcome more important than process. These can be things like ego, self-imposed expectations, commitment to an external party, financial dependence, or time parameters.

And then there's process. Painting is continual problem solving, and my daily block lies mostly in focusing more on the problem than on the solution. When I notice this feeling come up, I choose instead to be curious, engaged, present, and unattached.

I remind myself that my reason to paint is to explore, create beauty, and be in fascinated awe of how pigment can be used to tell a story or express an idea. I do my best to welcome the challenge and immerse myself deliciously in the adventure of solving it—for no reason other than to have the experience. If in the end, I don't knock one out of the park, I look for the learning. If I do succeed in what I'm trying to do, it's an extra-special, super-fabulous, happy-dance-around-the-studio bonus—with no expectation about what's coming next.

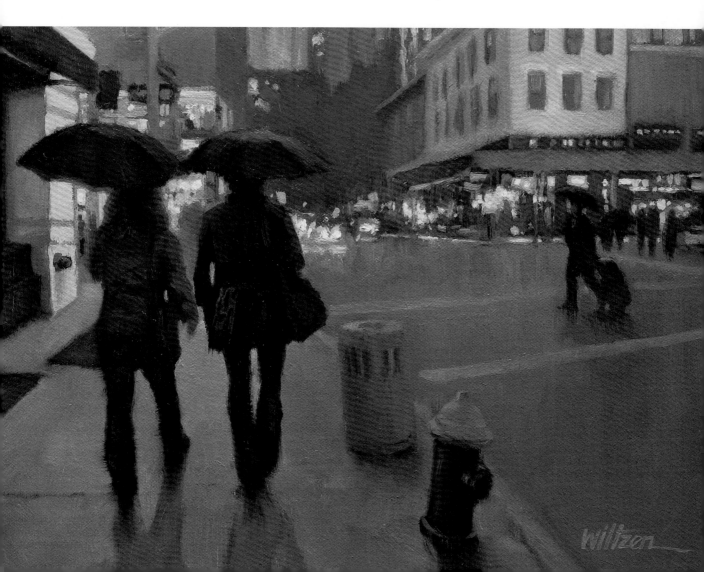

Brenda Ferguson

Reigniting the Passion

I feel lucky to be able to paint every day. But in a creative profession, one of the major challenges is staying fresh and passionate day by day, year after year. For me, it's not about not wanting to paint. It's more about running out of ideas that inspire me.

It's a solitary profession and I like that, but it can be hard to keep the motivation going. When there are stumbles, and there's no one in a cubicle next door to talk with about it, it can feel like we're the only one experiencing a dry spell.

It's a lot easier to do something when it comes genuinely and spontaneously from a place of passion rather than from obligation. How do we reignite that creative passion and maintain our enthusiasm? Some days it's just a matter of tweaking my thoughts from "I have to paint today" to "I get to paint today!" It's a subtle shift, but it adjusts my attitude and gives me back my power to choose.

When that's not enough, here are a few things that work for me:

- **Go backward.** I go back to a favorite subject or still life object or I look through old reference photos. Sometimes things that have been around for years and didn't interest me enough to paint them initially can reignite that initial spark.

- **Get your groove on.** Put on some music and crank up the volume. Music plays a huge part in my motivation. For me music and painting go hand in hand. If I'm ever having a hard time getting myself there, I put on some rocking music and, honestly, I just about run to my easel! These are surefire motivators: Jonny Lang; Mumford and Sons; Bruce Springsteen; Earth, Wind, and Fire; and Rusted Root, to name a few.

- **Talk with art appreciators.** Honestly, I'd rather spend my time creating art than talking about creating it. Having said that, when I start to feel like what I do is mundane, pointless, and/or not worthy of regard, talking with people who don't create art for a living can reinforce the power and beauty of what we do. I've talked with art appreciators about the energy they feel in a painting, the emotional connection, the details of the strokes, brushwork, color, and so on. Though they aren't creating art, they see the value in it when we may have forgotten, and the spark once again fans into a flame.

- **Use a life line: phone a friend.** Call a fellow artist and trusted friend. I'm lucky enough to have one of these all rolled into one person. A fellow artist and trusted friend understands the creative process *and* wants what's absolutely best for you. There is no competition or jealousy. Whether we're talking about her art or mine, we both get *pumped*! We listen, ask questions, exchange ideas, get excited, and in the end we've figured things out without even trying. By the time we hang up (usually because the phone batteries have run out) neither of us can wait to put on some music (see above), get to our easels, and

Brenda Ferguson, *An Apple a Day*, 6 × 6 in., oil on panel, 2013.

Brenda Ferguson, *Best Cat Ever*, 6 × 6 in., oil on panel, 2012.

create! This enthusiasm lasts for days and even weeks. So share some positive energy. Find yourself a trusted pea for your creative pod, and I guarantee that together you'll both rediscover the joy and reaffirm that there's nothing you can't accomplish.

- **Honor the ebb.** There are natural ebbs and flows in any long-term endeavor. When my creativity wanes and new ideas are not forthcoming, I try not to resist. Focusing on it only creates more stress and anxiety. Honoring the ebb of creativity doesn't mean begrudgingly or resentfully dealing with it. It means lifting the oars and easing into the trough, confident that in time, the next crest will come. I use the time to reflect on past artistic successes and accomplishments and to find other ways of creating like making soap, baking bread, or writing handwritten notes. Remain open to the possibilities.

AAA—Accept, Acknowledge, Allow

When my enthusiasm evaporates and my flow slows, I remind myself of a few things:

- Accept that it happens.
- Acknowledge that it's temporary.
- Allow my creative well to refill.

The bottom line is, even in the dry spells, I can't think of anything else I'd rather be doing. So I do this:

- Remember tomorrow's another day.
- Don't take it (art, myself, life, etc.) too seriously.
- Treat myself gently.
- Drink wine.

Brenda Ferguson, *Warm Wools*, 6 × 6 in., oil on panel, 2012.

Cathleen Rehfeld

Recognizing the Block

Sometimes I don't even recognize it as a "block"; I just start feeling that I don't know how to paint anymore or I'm generally not happy with the paintings I am making. Most of the time this happens after not painting for several days or weeks in a row, then I try to get back to it and feel that I don't know what I'm doing or why I should do it.

Getting Past the Block

Getting past the block means that you need to find some meaning to what you do, and a little confidence booster helps too. My blog has been incredibly helpful with this. Just when I am feeling like I don't know how to paint, someone sends me a comment saying something really nice about a painting! Then I think, "Okay, maybe I do know how to paint sometimes, and maybe I should get back to it." Often I have a weekly class to teach, which means I "have" to paint a demo, and that gets me back in the groove. It doesn't seem to matter how rusty I feel, doing a demo almost always gets me out of the funk I'm in.

You *Can* Take a Break If You Want To

Take the pressure off—if you want—just don't do any art at all. Go to a museum or art gallery. Sometimes the minute you take the pressure off, you will want to do art again right away. Or you can do something a little different—how about sketching or trying a completely different medium? There are many sketching Facebook pages (try Sketchbook!!) and websites that are very inspiring.

Meaning and Purpose

There can also be a feeling that maybe you aren't "helping" anyone with your skills. I'm not helping anyone's life be better in the way that a doctor or nurse might be very visibly helping others. Many people have innate talents that they have a natural inclination for, and maybe you don't get to choose how you use your talent. Maybe you just have to use your given talent and see what happens. Be open-minded and see where it takes you. Just go with it.

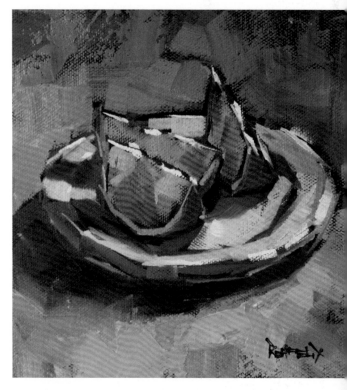

Cathleen Rehfeld, *Blues and Oranges*, 6 × 6 in., oil on panel, 2012.

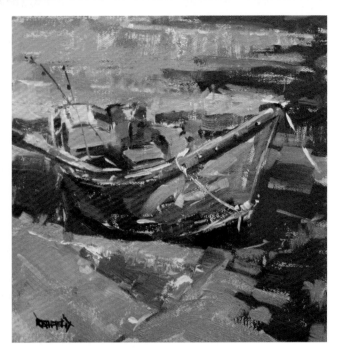

Cathleen Rehfeld, *Fish with Confidence*,
8 × 8 in., oil on panel, 2012.

Art Is of Value

It also helps me sometimes to remember that throughout history, people have painted, decorated, drawn, colored, designed things, and so on. People have always made art. Why is that? American Indians made intricate costumes using feathers, decorated leather, and the like. They decorated pottery, their daily vessels for carrying things, with drawings, textures, and colors. Was that frivolous? No. It was part of being alive, stimulated, and living a full life. Think about every culture we know about on the whole planet. They may barely have food, but they have art. Every culture has "fashion" or cultural types of dress. The Egyptians are a great example. Not only did they spend decades building elaborate pyramids, but the walls inside were covered with murals, and even the trinkets buried with the mummies were beautiful.

No Guilt

Most of all I think it's important that you not feel guilty or think what you're doing isn't valuable. Be you and be happy!

Cathleen Rehfeld, *Mt. Hood*, 6 × 6 in., oil on panel, 2012.

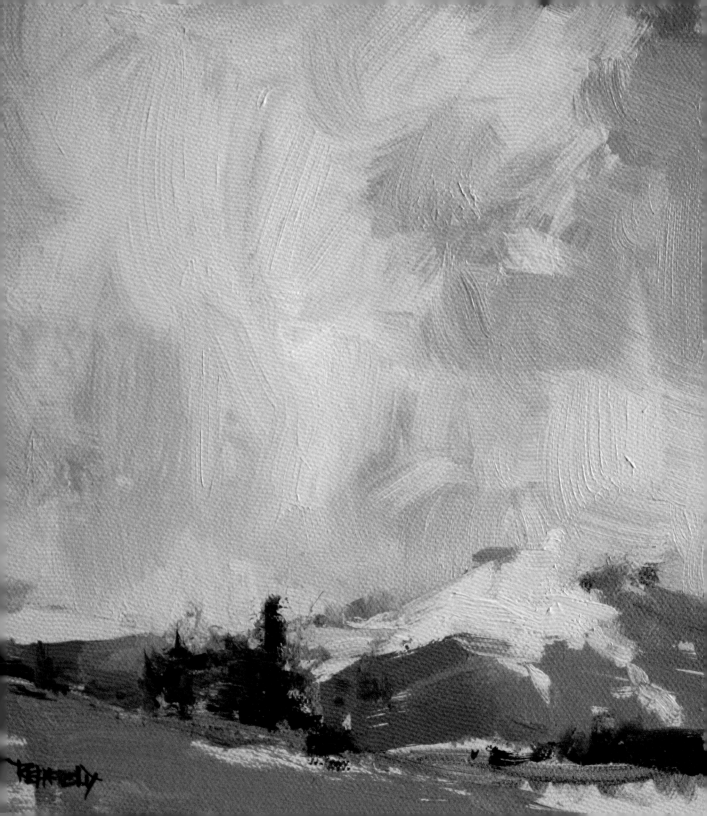

Crystal Cook, *Hoodie*, 10 × 7 in., watercolor on paper, 2013.

Crystal Cook

In January 2013 the awesome Leslie Saeta hosted a challenge to paint thirty paintings in thirty days. Thirty completed paintings. In thirty days. Sounds easy enough for a bunch of daily painters, doesn't it? I decided to give it a try, because while I do paint nearly every day, I don't always complete a finished painting in one day.

Since I've never met a challenge I didn't want to throw down with I thought Leslie's thirty paintings in thirty days had my name all over it. Little did I know that this would result in a pretty serious artistic block for me.

I learned some pretty big lessons with this challenge; here are ten things that it taught me:

1. **Don't ever run out of chocolate.** Seriously. Keep a secret stash somewhere or something. Trust me, you'll need it in those moments when the last three paintings you've attempted have resulted in nothing but a big pile of suckage reminiscent of the world's largest dung heap.

2. **Don't expect every single painting to be a masterpiece.** This was a hard one for me and something that a some of my good online painting buddies had to knock into my head a few times. It is highly unrealistic, and stressful, to think that every single thing you produce needs to be a huge success. And to stand before a blank piece of paper or panel with that thought at the front of your mind is just setting yourself up for disaster.

3. **Don't think you have to paint like anyone other than yourself.** To produce a finished painting every day, I sometimes thought that I needed to

paint like someone else, so I could paint faster, not like my detail-oriented, accuracy-driven self. And so some of the work I produced this month didn't satisfy me completely. It took me a while to realize that this is what was bothering me when I started to feel burned out; when I finally did realize it, I embraced the fact that I should only ever paint like myself, detail-itis and all. Because painting any other way, forcing myself to be "loose" when it doesn't come naturally to me at all, is being dishonest. And I believe that in order to paint with feeling and emotion, you have to be completely honest with yourself first.

4. **Everyone needs a dragon day.** In the middle of my burned-out period of the challenge, I started sculpting little dragons out of clay, just for fun. I did this on Sundays, which is my permanent day off from painting (thirty-in-thirty challenge or not, I still wasn't planning to paint on Sunday). When I was talking to my sister about how I was feeling so uninspired about painting, but so excited about making cute little dragons, she started calling Sundays my "dragon day." And I liked that idea so much that I now call Sundays my dragon day, whether I'm sculpting a little dragon or putting together a photo album or baking a new yummy treat. A dragon day is a day when you refill your creative well; it's a day to do anything creative that you want, just for fun, with no expectations that anything will come of it other than the joy you get from the act of creating.

5. **Don't try to paint a portrait (or any other difficult, complex subject) every single day for thirty days.** Just don't. Trust me on this. Portraits are my favorite thing to paint, but they are also very draining for me. I feel like I put more of myself into one of my portraits than I do into painting any other subject, so to paint them for thirty days straight would leave me nothing but a blubbering idiot by the end of the month.

6. **Don't doubt yourself.** Love thyself, fellow artist! Repeat after me: You is kind. You is smart. You is important. And you is a good artist. Don't ever forget it.

7. **Streamline your housework and meal planning.** Or whatever other work you do. Now is not the time to volunteer to bake your son's class personalized cupcakes with each child's name iced in calligraphy. Now is not the time to deep-clean your basement and closets. Now is the time to do the basics of housework and cook reliable, family-favorite meals.

8. **Keep yourself surrounded with things that inspire you.** Visit other artists' blogs and websites that leave you breathless with their beautiful work! Read books or magazine articles, or listen to podcasts that talk about the life of an artist, their thought process, and what they do to stay inspired. Pin an inspiring quote, favorite photos that you want to paint, or pictures above your workspace to motivate you. Keep a journal of the things you see in your daily life that make you pause and see how beautiful your life really is. In other words, enjoy the journey that is your life.

Crystal Cook, *Grapelight*, 5 × 7 in., colored pencil on pastelboard, 2013.

Crystal Cook, *Haven*, 5 x 7 in., oil on panel, 2013.

9. **Forgive yourself.** So you didn't do thirty paintings in thirty days—you only did seventeen. So what?? You tried, you painted your heart out, and you accomplished great things anyway. If you need further reassurance, go back and read #6 on this list.

10. **Recognize that this challenge is more about the journey than the destination.** Trite perhaps, but it's so true. It's not a race; there's no need to compare yourself to anyone else. This challenge is about you and your art and what it means to you and no one else. It's not about the end result; it's about the process of painting and the joy it brings you.

Bruce Bingham

Sneaky Devils

If we paint or create often enough and long enough, it's inevitable that we will encounter some blocks, a bad day, bad month, and sometimes a bad year or, worse, years. These artistic pitfalls can take the form of a bump, a slump, or a creative black hole. They are sneaky devils as well. You never know if they are going to creep up on you slowly or attack when you least expect it, hitting you over the head, suddenly, from behind, with a cast iron frying pan, again and again. I've visited these places many times to various degrees over thirty-five years of professional painting. To those lucky souls who have escaped this experience, I say, keep working, you'll get there!

This is not the end, my friend, unless you allow it to be. We all know it's darkest just before the dawn. If we persevere, these struggles become a breakdown (mini or major) that helps lead us to a breakthrough. These, um, "opportunities for learning," once the enemy, later become our friends that gave us the motivation to make a necessary change, gifting us with more satisfaction in our art making.

When to Seek Help

Have you ever had any of these thoughts?

- I'll never be a good artist.
- I start out okay but ruin it before I'm finished.
- I don't know how she or he painted that; I could never do that.
- There is some secret key I'm missing.
- I don't have talent.

- A smarter person would have quit by now. (My personal favorite!)
- I hate my studio and my paintings.
- Why do they always get recognized; they're not any better than I am.
- I always get overlooked.
- My kids, parents, friends (insert your own words here) *need* me.

This list could go on for pages, as we all know, but before you drive off the nearest bridge, why not read the good news?

Bruce Bingham, *My French Window*, 12 × 12 in., oil on panel, 2013.

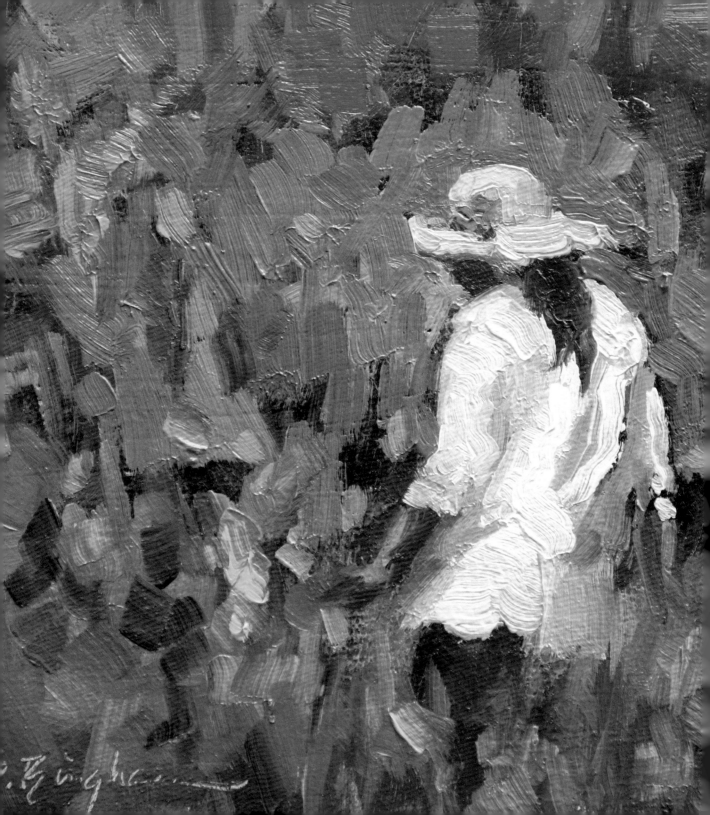

Life, with all its surprises, will present each of us with challenges that are both unique and universal. Twists and turns create detours in even the best-laid plans. Things happen: marriage, kids, divorce, marriage, kids, divorce (just checking to see if you're still paying attention), moving, shifting economy, aging parents, health challenges, financial needs, and more. Is it really fair to expect ourselves to always be on top of our game with everything that we have going on in our lives? To set unrealistic expectations and pressure ourselves only leads to a vicious cycle of failure.

A Fresh Perspective

Often the cause for our dissatisfaction can simply be a technical issue that we're overlooking. This can more easily be identified by someone other than yourself. Beware here and use caution when seeking advice. Don't ask your cousin or your friend from the book club. Ask the advice of someone who has experience and whose work you admire. It's possible they will pinpoint a basic fundamental artistic principle that you can use to strengthen your own practice and that will give you back your creative zest.

The Million-Dollar Question

This is the million-dollar question: How can I create a satisfying art life and share my unique gifts with others without getting burned out? Truthfully, you probably can't. Life has ups and downs, but you don't have to fall off the face of the earth, never to return. Try to set a reasonable pace and realistic goals for yourself. When you start to lose your balance, learn to read your early warning signals. For me, when I paint too much or when I don't paint enough, I get grouchy. That's my red flag to make some adjustments. Deep within you know what you need, whether it's to ask for help, phone a friend, or take a class. But only you can determine your attitude. Our attitude can defeat us or inspire us to create new paths to success. If you can change your mind-set, you can shift your circumstances, although it might not be easy, but remember, you are not alone.

Bruce Bingham, *Blue Shutters*, 8 × 8 in., oil on panel, 2013.

Bruce Bingham, *Walking in Lavender*, 6 × 6 in., oil on panel, 2013.

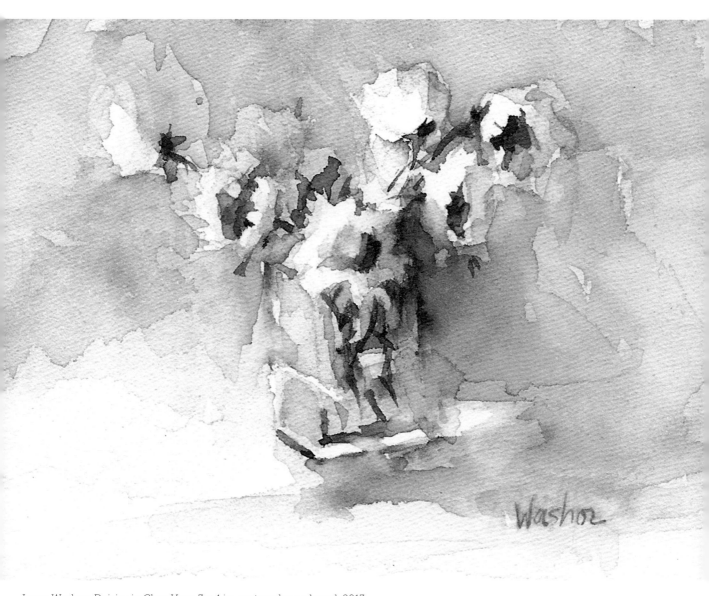

Joyce Washor, *Daisies in Clear Vase*, 3 × 4 in., watercolor on board, 2013.

Joyce Washor

Major Blocks (Versus Mini Ones)

I get mini blocks that last a couple of hours and also major ones that can last weeks or months (all of them feel like infinity). When I feel it in my head, there are certain immediate tricks that I resort to. When I feel it in my bones (just a dead, tired feeling), I know it's a major block and I rely on other methods to get myself out of it.

The first thing is to recognize what's happening. This can be the most difficult part. I can spend a week not knowing that I haven't been painting, but doing chores instead. I was spending too much time avoiding the work that needs to be done to get back to work!

Once I find myself thinking, "I'm just not interested in painting anymore," "There's nothing left to paint," "Everyone else is so much better," I know I'm facing a major block!

The next thing to recognize is that it's okay. It's natural to be tired. It's how the artistic process works. You let it out, and then you need to fill up. Sounds like breathing!

I have found some things that will help this healing process along:

- **Go for a massage.** (I put this first because it's my favorite!)
- **Go for acupuncture.** (This gets the energy unblocked just like a massage.)
- **Take a short trip.** (The older I get, the less I do this one.)

- **Take a workshop.** (Ditto.)
- **Watch a DVD.** (I like to keep one on hand to watch if I get to the point that I'm feeling blocked.)
- **Read a technique book.** (You could read one of mine!—*Watercolor Harmony* or *Oil Painting Harmony*.)
- **Read an inspirational book or one on being blocked.** There are lots of good ones out there. I recommend *The Artist's Way* by Julia Cameron.

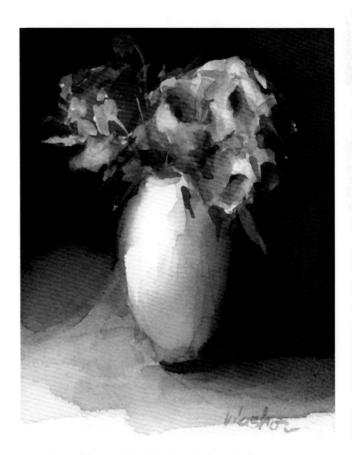

Joyce Washor, *Floral Study with Dark Background*, 4 × 3 in., watercolor on Board, 2011.

While I'm doing this, I tell myself that I don't have to compare myself to anyone else. We are all on our own trip. When I was about to teach my first workshop and was very nervous, the workshop coordinator gently told me that I was simply teaching my way of doing art. No one was going to say I did it the wrong way. The same is true of painting. This took away all the self-judging and allowed me to be myself.

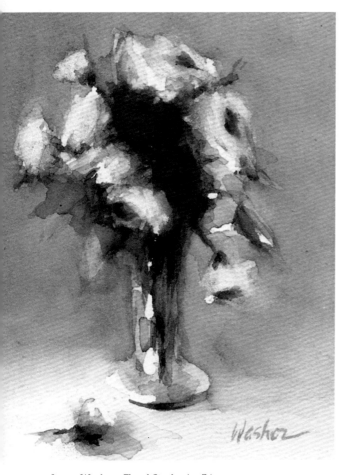

Joyce Washor, *Floral Study*, 4 × 3 in., watercolor on board, 2011.

Mini Blocks

If I don't have that tired-to-the-bone feeling, I use a different strategy to counteract a mini block. You could use these tricks when you feel like you're having a mini block:

- **Keep your checkbook or some other task that needs finishing near your work table so you can have a reason for sitting at that place where you do your painting.** You're there because you need to write a check to so-and-so, but then you might find your mind wandering to your work! And then, before you know it, you'll be painting!

- **Break it down!** By that I mean, don't think you have to do a masterpiece. (I don't even like to think it has to be a good painting. For me, the best frame of mind is when I'm thinking, I want to be a better painter; I'm going to try this today.)

- **Give yourself a small task to finish.** For me, it's usually this: "Joyce, just set up the still life," or even smaller is, "Just go out and get a good-looking onion to paint!"

- **Write yourself a permission slip saying that you have time to do something for yourself.** You can be specific or very general. Mine usually say, "I give Joyce Washor permission to spend the entire day painting her still life in either watercolor or oil without having to have a finished product at the end of the day." We all need playtime and sometimes we even have to give ourselves permission to be an artist. So be it! This permission slip can be from your parents, teacher, spiritual leader, or spouse! I've used them all! The idea is that you are allowed to be yourself without any commitments. (Wouldn't it be great to be able to work this way all the time?) I see this as the best vacation ever! Then sign the slip using "authority's" name. You are now officially free to paint!

10

How to Photograph and Edit Small Paintings

Why Do You Need Pictures?

Before you decide *how* to take pictures of your art, you need to know what they will be *for*. For example, if you want to make high-quality, giclée prints of large paintings to sell, you might consider a professional scan. If you are making slides for a major show or contest, consider hiring a professional who photographs art on a regular basis.

If you want to take high-quality photographs of large paintings on a regular basis for record keeping, making high-quality prints, entering shows, and so on, I recommend taking a class or reading a book on photographing art. You'll probably need to invest in lights, stands, umbrellas, filters, and, possibly, cameras, lenses, and so on. This is a big investment, but in the long run, it saves you money over hiring a professional to take pictures for you every time.

For recording small work, selling it online, and even publishing a small book, you don't need to spend a lot of money. I have an easy method for taking pictures outside that has worked well for me for many years and provided the images for five books, including this one. Your only expense, besides a computer, is a camera, and possibly some photo-editing software.

My camera and a few of my small paintings.

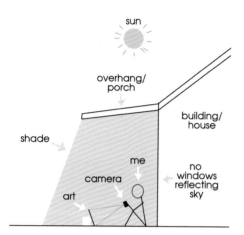

My method for taking pictures of my art outside: Find open shade (porch optional), point my art away from any light source, prop up my art, sit down, get square, and shoot!

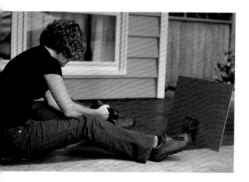

Here I am taking a picture of my painting for the day. My elbows are braced on my knees so I don't shake, and I have on striped socks.

Cameras

I recommend a digital camera. I currently use a Canon PowerShot G12 (pictured on page 159), which I love. Before that I had two Sony Cyber-shots, which were also great. Make sure you keep track of your camera. I actually thought I'd lost one once so I bought another. I found the original the next day hanging on a chair in my studio. D'oh.

Just about any digital camera purchased since 2000 will work. Make sure the MP (megapixel) resolution is above 6—that way they are sure to be large enough for most needs. (Actually, I'm not sure you can buy a camera these days with fewer megapixels!) You can get a decent camera for as little as $100.

I prefer a large LCD panel or screen because it makes it easier to see what I'm photographing (on a related note, if you like to take candid pictures of people for paintings, a swing-out LCD screen is an extra bonus). This can sometimes cost a little more.

Finding a Good Spot and Shooting

The tough thing about taking photos of oil or acrylic paintings is—glare! To avoid glare, you need to find the right spot, and I like to start outside. Natural light is cheaper and requires far less color correction in the end. Here's my approach:

- **Find a spot in open shade (not too dark or closed in).** I find standing in the shade of a building and facing your art *toward* the building is usually a good starting point—with your back facing the wall (see image at top left). Basically you don't want your art facing any light source, and not just the sun but the whole sky! Make sure there are no windows on the wall behind you, reflecting the sky or any other light source. You'll get an extra great photo if there is an overhang above you. My favorite spots have always been on porches.

- **Just to make sure, hold your art out in front of you and turn in different directions.** When you see no glare on your painting, put it down against something safe so it doesn't fall/blow over, with nothing in front of it, like blades of grass.

- **I find it very useful to have a piece of cardboard behind my art.** This helps stabilize it, provides a nice, solid, midvalue background, and blocks any light from behind it.

- Next, sit down and make yourself into a human tripod by putting your elbows on your knees. If you are still shaky or can't get into this position, put your camera on a tripod and your work on an easel or something else to raise it.

- It is very important to zoom in a little if you are using a point-and-shoot. The default is wide-angle, and if you don't zoom in the edges of your painting will be warped in the photo. The way to check this is to load the photo on your computer and crop it. If the edges aren't straight, take the picture again, with more zoom.

- Make sure your camera is as square to the painting as you can manage! If your painting is at all key-stoned (wider at the top than it is at the bottom or vice-versa), it will be very hard to edit later. This is tough, but very important. Basically you want to make sure that each edge of the painting is parallel to the corresponding edge in the LCD panel. I end up taking several pictures just to make sure I get one that is square.

I like to flip out my LCD panel and point it up at me so I can see if I am square to the painting.

You don't necessarily want to fill the frame with your painting. If your painting is very dark and you fill the frame, the resulting photograph may be over-exposed (too light). If your painting is light and you are too far away it may be under-exposed (too dark). The trick is to look in the LCD panel as you get closer and further from your painting. When it looks "right" there, take the picture.

Make sure your camera's output is set to RAW or to high-quality jpeg format. You will find this in your camera's settings. Unfortunately every camera is different, so I recommend looking at your manual if you don't already have this figured out. My camera gives me MP (megapixel) options (I can set it to 10, 6, 2, or 0.3). I have it set to 10 MP, the highest it will go.

Don't use a flash! This creates glare, which is exactly what you are trying so hard to avoid (see at right).

My advice is to take several pictures, resquaring each time. Also try different spots around the house, at different times of day. Make notes so that when you check the photos, you can decide which places and times produced the best photos. After that you can rely on that one spot and time.

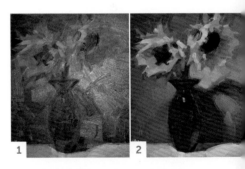

1. *Awful!* One of my paintings taken with a flash. **2.** *Sharing the Red Dress*, 6 × 6 in., oil on panel, 2013. Same painting, taken with my regular method—no flash.

Editing Tools

Once you have successfully transferred your images to your computer, you must choose which software you will use to edit them. You have plenty of options. The more sophisticated of them are the most expensive. If all you want to do is put your images online, you can opt for less sophistication and save money.

Below are a few of the most popular options. It is by no means a comprehensive list, as they are coming out with more all the time. Unfortunately these tools are always changing, so by the time you read this, some of the information may be outdated. For that reason I'll just give an overview of each one. That said, I sell an online tutorial ($10) that details all the steps for opening, editing, and saving a painting for each individual program on dailypaintworks.com (click on "Art Tutorials").

Photoshop

I use Photoshop. It is the most versatile program but relatively daunting if you've never used it before. It is also very fairly expensive to use or buy. If you already have or subscribe to it and know how to use it, great! If not, I recommend buying a book about your version, as I did.

Photoshop Elements

Another, less expensive option is Photoshop Elements ($70–$100, depending on where you get it). It is much more user friendly than the full Photoshop, and it's really all you need for posting your paintings on the Internet.

iPhoto

I am a PC person, but if you have a Mac, you are probably familiar with iPhoto. It comes free with any Apple computer. iPhoto's cropping and saving tools leave a lot to be desired in my opinion, but otherwise this is an okay tool.

Picasa

Another free option, for any computer, is Picasa. This is a Google tool and somewhat limited, but it's still usable if you are willing to compromise somewhat when it comes to cropping and adjusting values and colors.

iPiccy

This is another free option that is only a tiny bit less useful than Picasa: iPiccy. You don't have to actually download it (you use it right on the Web).

Basic Steps for Editing

Regardless of the program you use, there are some basic steps you will want to take to edit your painting and make it ready for use.

1. **Open your file.**

2. **Crop out *everything* that isn't your painting!** To crop badly or not at all is incredibly unprofessional. If you find the photograph wasn't quite square, take the photo again.

3. **Adjust the values** (aka "levels" or "histogram"). This tool often shows a graph with three little triangles underneath what looks like a mountain range. Grab these triangles and move them around, watching how the image changes as you do so. The goal is to make the image look *as much* like the original painting as possible (don't make it look better!).

4. **Adjust the color balance (if needed).** Unfortunately each editing program handles this differently. If you can't find the color adjuster, try Googling it. Once you find it, try to make the image (again) look as much like the actual painting as possible!

5. **Fix any blemishes.** Most programs have a clone stamp tool or something like it for this. It is important not to fix the painting, but rather remove spots in the photo, like raindrops, or dirt that has been removed (page 164).

6. **Save a large version.** At this point you have a large, edited version of your image, and you should save this under a different file name than the original. I always like to keep my original file (just in case); a large, edited version (what we're saving in this step); and a web-ready version (which we'll save in a minute).

7. **Change the image size.** To load quickly on web pages, your file size must be manageable. I like to change the pixel width to something between 500 and 1,000 pixels on the widest side. This should automatically change the pixel height, keeping the image in proportion.

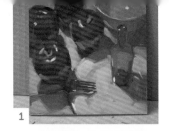
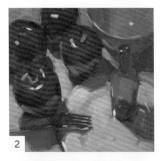
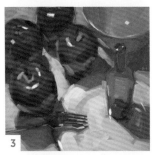

1. An unedited photograph of one of my paintings—straight from my camera. **2.** Here I've cropped out everything that isn't my painting. **3.** Here I've adjusted the values to make it as much like my painting as possible. **4.** Here I've adjusted the colors just a little—my camera tends to take pictures that are too blue.

I used the Clone Stamp tool to remove this raindrop from a painting.

I keep all my art recorded on my computer, so this is just a mock-up, but you can see how each painting is numbered, and all the pertinent info is there.

8. **Save for the Web.** All programs save differently. I very much prefer the way Photoshop and Photoshop Elements do this, as they give you the most options. For these programs you need to save the file as a "JPEG" and adjust the quality level so it's somewhere between 70 and 80 (in my opinion). This makes the file size even smaller but not so small that the image starts to look bad.

Stay Organized

Number Everything

It is essential that you stay organized with your art and computer files. If you haven't done it yet, start now! I recommend titling and numbering all of your photographs. My standard naming convention is "Number_ Painting_Title." Numbering the paintings chronologically helps me not only keep track of them all, but also chart my progress over the years. I use my blog to track the date, but if you don't blog you may want to include the date in the file name.

If you'd like to save more than one version of a painting, but have a preferred version you'd like to post online, come up with some sort of naming convention that helps you remember which version is final. (I use the phrase "Web Ready" in the file name—for example, "Number_Painting_ Title_Web_Ready.") When I upload unedited photographs to my computer, I save them as "Number_Painting_Title_Original_1."

You should also keep an organized list—either handwritten or digital (I recommend Excel) of all your work. Record the number, title, date completed, size, media, price, where it currently is (studio, gallery, show, etc.), date sold (or donated, gifted, etc.), who bought it, and any other pertinent information.

Stick with It

However you choose to organize yourself and your files, don't give up! You will thank yourself down the road when someone asks for a copy of *Night on the Town* and you know exactly where the painting *and* the file is, can access any size version for them in a couple of minutes, and can tell them if the painting is sold or not. Believe me.

11

Tips for Better Online Sales

The great thing about selling art online is it provides exposure and opportunities for artists who feel limited by the gallery system. In the old days, galleries were the main gatekeepers, and it was tough to make a name for oneself without them.

But there were and are challenges associated with being in galleries. First of all, you have to get into one, which can be tough. Then you have to be willing to give the gallery a big cut (usually half) of every sale. I found I had to check up on some of my galleries to make sure my work was even hanging, and I had to hassle a few to get paid. Sometimes my galleries would organize PR for me, but if they wanted to advertise, I was asked to chip in. I had to frame all my work in a different style for each gallery and then get it there safely, which often meant hefty shipping and insurance costs. Then around 2008, a lot of my galleries started closing down, and some said they couldn't afford to ship my work back so I had to pay for that too. Finally I got so frustrated I pulled out of all my galleries and started selling *all* my work online.

A snapshot from my first one-person show, at the Wally Workman Gallery in Austin, Texas, 2009.

If you choose to sell your art online, you will find challenges there as well, but it may end up being a better fit for you, as it has been for me. There are definite costs associated with selling online: marketing costs, auction fees (if you use them), and payment transaction fees (my customers pay me via PayPal, which charges me a little over 3 percent). In total, these expenses are about 12 percent of what I make—far less than the 50 percent I would be paying a gallery. That means for every $100 I make, I keep $88. Another challenge with selling online is that it demands time and attention. I spend at least an hour total every day photographing my work, posting to my blog, *Daily Paintworks*, and to Facebook, shipping any paintings that have sold, and answering questions from fans via email (this last one takes up the biggest chunk of time, but I don't mind it).

Another challenge of selling work online is that not *everything* sells well. I have found that smaller, affordable work tends to sell much better online than larger, more expensive work. I theorize that people are less willing to buy something they can't see in person if it's very expensive and hard to see in detail on a computer screen, rather than if it's small, easy to see, and under $500. That's definitely something to consider before you start pulling your work from galleries. A lot of artists end up doing both—selling larger work in galleries and smaller work online.

Setting Your Best Foot Forward

Before you run off and start promoting your work online, it's a good idea to make sure what you're selling is top notch, your presentation is welcoming and attractive, and your work is easy to buy.

Be Proud of Your Art

Being objective about your own art is a tough thing. Here are a few questions you can ask yourself to help figure out if you are ready to sell:

- Are you proud of your work?

- Is the quality consistent?

- Do you think other people will want to buy your work and hang it on their walls?

- Are you motivated to sell because you have a bunch of paintings sitting around or because you actually think you're ready to start selling?

- Are there some paintings you can weed out? Show only your best.

If you're not comfortable asking these questions of yourself, consider asking someone you trust (preferably not a close friend or family member). The best person to ask is a professional artist you admire, and the best way to do it is in person.

Beautify Your Online Presence

There are a lot of things you can do to improve your blog or website. Try to look at your site again from a fresh perspective, as if visiting it for the first time—better yet, from the perspective of a potential buyer who has just found your work.

Your header is the panel that will appear at the top of your webpage. It is probably the first thing a visitor will look at, so I strongly recommend adding your name up there somewhere, even if it is not part of the title of your blog. This is what you want to be remembered by in the long term—your art, of course, and your name. Most blog platforms, such as Blogger (blogger.com) and wordpress.com, have a default header that varies by template. A lot of artists go one step further and create a fancy header with a painting in the background and custom text. I think this goes a long way toward livening up your site. Look at blogs you like for ideas.

A sample header I created with my own painting in the background.

Be sure your header isn't too tall. There is a term in the newspaper world that is also used in web design, called "above the fold." Basically, you want to make sure that important content is visible on-screen as soon as people load the page so they don't have to scroll down to read the "headlines." If the header takes up the whole screen and your customers can't see the new painting each day without scrolling, you are making it that much more difficult to buy. It's a little thing, but every little thing counts online.

Personalize Your Blog and Website

In my experience, buyers love to know the artist. A face and a story give the buyer a connection to you they wouldn't have otherwise. They are proud to tell your story when a friend comes to their house and comments on your art hanging on their wall. I recommend including a nice, friendly picture of yourself on your blog, even if it's not in your header.

You don't have to write anything on your blog other than information about each painting, but if you do, don't be afraid to add little personal details—just don't go overboard. What I figure is that most people are more interested in my paintings than my words, especially if my words are unrelated to art. I try to keep my posts short and light and mostly about art, unless there is something serious I want to share. That said, I also use a slightly less formal, personal tone so that my readers get a sense of the real me.

Organize and Declutter

More is not more when it comes to web design. A blog usually has a narrow sidebar, on the right or left, with lots of fixed information about your site—your personal info, contact info, blogs you recommend, an archive, buy links, and more. But make sure that you only include essential information here. Try to order this information so the most important is at the top. There is no right or wrong way, but I like to start with a short blurb about who I am, then my email list, then more about my affiliations and workshops.

If You Don't Have a Blog, Get One!

A blog *is* a website, but for our purposes, I'd like to differentiate between a blog that is updated often and like a journal, and a static website filled with mostly old work that sits around getting dusty. Having both is fine, but if I were to pick one, I would definitely recommend starting a blog! Here's why.

Number one, it's free. Number two, it's super easy to post. And number three, people don't really have any reason to visit a website that doesn't change often. Your blog will keep people coming back. Your static website will not. I find that readers stay engaged if I post something new once a week, at the least.

Make It Easy for Buyers to Buy!

This is possibly *the* most important part of selling online! There is no way I can emphasize it enough. I find so many artists who make it downright *difficult* to buy their art, and that is simply not good for sales. You want to make it as easy as possible.

At the very least, I recommend you be easily contactable. Include an email link somewhere—preferably in more than one place. I have one on my blog, one on my website, one in the email I send out, and several on Daily Paintworks.

But better than that is to think like a buyer. Let's imagine you just inherited $1,000 and you want to spend it *all* on original art. You visit an online gallery like Daily Paintworks and see lots of great stuff. You find a few artists you like and start looking at their galleries and blogs. You fall in

A screenshot of my blog from September 16, 2013.

Donna Walker, *The Tender Land II*, 16 × 16 in., oil on canvas, 2012. A decluttered landscape, inspiration for decluttering your blog!

love with one particular painting, but the buy link says "Contact artist for price." You think, "Whoa, this painting may cost more than I'm willing to pay. That would be an embarrassing situation. And I'm emailing an *artist*—who knows when they will get back to me? I want to buy a painting now." So you choose a different painting. Or spend your money on a new TV instead. I've been there (minus the $1,000 inheritance) and it's frustrating! The solution?

Give them a price up front and a link to purchase the painting!

There are lots of options for selling: for example, you can list your art on etsy.com, ebay.com, dailypaintworks.com, and the like—and use their built-in purchasing systems and/or you can list on your own website and embed PayPal "Buy It Now" buttons. Choose one approach and stick with it. Or, feel free to try them all, but make sure you don't list the same painting in more than one place at the same time. If it sells in two places at once you'll have a problem!

Generating Web Traffic

One of the biggest challenges of selling online is getting eyeballs to your blog or website. Let me just say up front: there is no easy way to generate traffic. And what works for one person may not work for another.

Here's some general advice I have before we get started with specifics:

- **Don't put all your eggs in one basket.** Try lots of things. When something finally sticks, go with it!

- **Finding a niche is often a good way to go, like choosing a particular genre or style.** Make sure you are passionate about that niche. If you paint what you don't love, it will show in your work.

- **Figure out what your market is and go after it.** For example, if you paint pet portraits, consider advertising in pet magazines or websites, put up flyers in pet stores, email pet bloggers and ask them to feature your paintings, donate a custom pet portrait to a charity raising money for animals, and so on.

- **Be in it for the long haul.** If you are going to try marketing your work for one month as an experiment, you are doomed to fail! Give it time to work.

$100 click here to buy!

Over-enthusiastic, 6 × 6 in., oil on panel, 2011. Make it easy for buyers to buy! Give them a link!

Bowl-Egged, 6 × 6 in., oil on panel, 2012.

Once you've sparkled up your site and clarified your selling techniques, you'll definitely be ready to find some readers. There are two main ways to do this: one takes time and the other takes financial investment.

Comment on Other Blogs

This is a great (and completely free!) way to join the daily painting community. By commenting on other people's work (via your own blogger profile), you are not only spreading the love, but also posting the links back to *your* blog every time you comment! (If you have a blogger blog and you comment on someone else's blog, anyone reading that comment can easily click on your name or photo and go to your blog.)

Another benefit of commenting on art you like is it quickly leads to online friends! And friends are good to have. You know what they say: "It's all about *who* you know!" When I first started posting, I commented on the blog of Karin Jurick, a very popular artist and blogger. She then posted about me on her blog as someone to check out, and I literally went from selling a few paintings a month to selling half of everything I did—overnight! I'm not saying this will happen to everyone, but it is worth networking with other artists, regardless!

I have also commented a couple of times on posts by Robert Genn (Painter's Keys) and my comments were featured *and* included an image of one of my paintings. Both times I got tons more hits on my blog than on any other, regular day.

How should you comment? Well, needless to say, any comment you post on an artist's website should be honest, authentic, and from the heart. Try to provide meaningful feedback—a clipped "This is great!" won't generate as much traction as a more elaborate comment with perhaps a question at the end, for example, "Your strawberries are great! I was painting them last week and had trouble suggesting the seeds. You make it look so easy! Any tips?"

Trade Links

Most artist bloggers include what is called a "blog roll" on their sites. This is basically a list of blogs and websites (with links) that the artist endorses—it usually appears on the side of the webpage. Often you can ask other artists to "trade" links with you (they add you to their list and you add them to yours). The reason you want to add this is twofold:

These are just a few of the artist friends I've made online. I threw a Bad Art Destruction Party, where we destroyed some of our old work that was sitting around making us feel bad. These were the friends who lived close enough to attend.

1. The more links you have out there, the more chances buyers have of finding you.

2. In Google searches, the sites with more links out there pointing back to them are ranked higher. So the more links other folks have back to your blog, the better off you will be.

Start an Email List

It is important to have a way to notify your fans when you post something new. Otherwise people may find your blog and then forget about it. So you want to give your viewers a way to sign themselves up. Currently, Feedburner will do this for you for free and automatically send out an email to all your fans after you post. To set this up in blogger, visit your "Layout" page and click "Add a Gadget." Choose "Follow by Email." Click "Save" and you're done!

I recommend letting people add themselves to your list. We all get enough email as it is—let people choose to get more from you. What *is* okay is sending an email *once* to everyone you know, informing them of your blog and letting them know that they can sign up to get regular emails if they so choose.

Use Social Media

Facebook, Twitter, Pinterest, LinkedIn, YouTube, and so on are being used widely by artists today. In my opinion it's difficult to use all of them all the time (who has time for it?!), but the potential for exposure is huge.

For example, if you have one hundred friends on Facebook and five of them *like* a painting you post, you'll be seen by the friends of those friends too! You can also create short, instructional videos on YouTube with links to your paintings, tweet your latest happenings, make new friends on LinkedIn, and so on.

Participate in Forums

Joining and participating in art forums is a good way to network and get help with questions or problems you may have. You can also find new artists to trade links with and generally make new connections. Try a Google search for "art forums" and you will find a number of popular ones to join. Choose one that is right for you.

Nora MacPhail, *Chat*, 5 × 7 in., pencil and watercolor on paper, 2013. Old-fashioned socializing.

Enter Shows, Contests, and Challenges

While these are time-honored ways to market yourself as an artist, it is important to know what your potential exposure will be before you commit your time (and sometimes money) to them. Small local shows might be cheaper and easier to get into but may also have a limited exposure, whereas bigger, international shows might put your work in front of more eyeballs but be harder to get into. Another consideration is online contests. They are often less expensive, *and* you don't have to ship your paintings.

Make Special Offers, Have Giveaways, and Donate to Charity

Sometimes a special offer or two can liven up your sales. There are tons of things you could offer, but here are a few ideas:

- Free shipping if the painting is over $100
- A free frame for your first customer each month
- Gift-wrapping around the holidays
- Buy one, get one half off

You can also motivate people to sign up for your email list by giving them an incentive. I know several artists who do a monthly painting giveaway by randomly choosing a winner from their email list.

When you donate your work to charities, you have the potential for not only getting new eyeballs, but also helping out a cause. For both the giveaway and charity, though it can be tempting, I recommend *not* donating your worst work. You don't want that out there representing you—the whole idea is to create buzz and excitement!

Send Out Press Releases

For this I recommend having a strategy that starts small. For example, if you send press releases to local papers and magazines and your story is picked up, you are much more likely to get picked up by bigger newspapers, TV or news shows, and magazines.

Gift and Grapes, 6 × 6 in., oil on panel, 2011. Giveaways can be a great way to boost sales!

Do research to find out exactly what a press release should look like these days, whether it should be emailed, who exactly to send it to, whether to attach images, how many times you should call after it goes out, and so on. This stuff changes all the time, and you should be up on the latest.

You also need to have a story worth publishing. For example, if you sent out a press release about plein air painting while naked, you would probably be more likely to get a story than if it was only about plein air painting. Right?

Advertise

This is where your marketing efforts are going to start costing money rather than just time. There are many kinds of places to advertise and a wide range of costs. We'll start with the cheapest.

Join an Online Gallery

There are lots of online galleries but just a handful that are specifically for daily painters. Before you choose one, you should check out their traffic and make sure their monthly advertising fee matches your potential exposure. You should also check out how difficult it is to post your art to their site. Some will pull from your blog automatically, and some require you to post manually every day. Daily Paintworks is an option, but there are several others. I won't mention them all here because this stuff is always changing.

I call this advertising because you are paying these sites for exposure. I consider them to be a great deal compared to other forms of advertising. The cost is generally low, and the exposure is high.

Claudia Hammer, *Working on a Crossword Puzzle*, 18 × 18 in., oil on panel, 2013.

The great thing about daily paintings for the collector is they can be purchased one by one and hung in a collection like this.

Advertising in magazines is something to consider. Here are a few of my favorites.

Buy Online Ads

There are probably lots of places online where you could advertise, but two places we have had luck are on design blogs and Facebook.

- **Design Blogs:** There are quite a few blogs out there all about interior design (like designsponge.com and 79ideas.org (Google "interior design blog" for lots more). The people who visit are looking for ideas about decorating their own homes, and since they're doing it themselves, they're probably on a budget. The brilliance of daily paintings is they are small and usually not very expensive. Instead of investing in one large, costly painting to fill a space, people can create their own unique collection, one piece at a time.

- **Facebook:** The great (some would say evil) thing about Facebook is that they collect all kinds of information about their users and then utilize it to sell advertising. We (Daily Paintworks) have used this to target what we believe is our art-buying audience. Basically, you can choose who will see your ad. For example, we chose women (because most of our buyers are women), above thirty-five years old, who marked art as an interest. You can tell Facebook how many clicks you are willing to pay for and as soon as that has been reached, the ads stop for the month.

The good thing about advertising online is you can count your clicks and compare them to how much you are paying to determine which ads and sites are working well for you.

Buy Ads in Magazines

Magazine ads are more expensive than online ads, and you have no real way of knowing how many people you are reaching. When Daily Paintworks had only twelve members, we took out a quarter-page ad in *American Art Collector* for four years (at $800/mo.) and saw our stats rise only painfully slowly. This is not to say advertising in magazines does not work, but in my opinion, they cost a heck of a lot for the results we got.

That said, you could consider advertising in magazines that aren't art related. For example, if you paint pet portraits, you might be better off advertising in pet magazines.

Print Stuff

Take every opportunity to hand out brochures, postcards, business cards, and one-sheets with your name, art, URL, and contact info on them. I like to include a business card with every painting I sell, and I also carry them around to give to random people I meet. Make sure you have a "wow" painting on it!

I've used a lot of different services for prints, but so far my favorite for paper stuff is (amazingly) the cheapest! I am sold on Vistaprint. My business cards always turn out great, as do the stickers I get for my workshops.

You might also consider printing other things, like T-shirts, mugs, magnets, hats, aprons, and so on (CafePress). And books (Blurb or MagCloud). I have had a good run the last four years, making one book each year (a collection of one hundred paintings). The great thing about books is that people buy them and (hopefully) put them on their coffee tables, where friends who come over see them, ask about them, and are sent to my blog! Another positive for using a service like Blurb or MagCloud is that there's no initial investment other than the time you spend putting a book together. These companies handle all the sales for you, print each book on demand, ship them to the end customer, and send you a check at the end of the month.

Here are a few examples of my own promotional materials: a book, business cards, and a postcard.

Get Professional Advice

If you've already tried all my ideas, or you need something more specific for your niche, I recommend getting advice from a marketing professional, either in person or from a book or radio show.

Listen to *Artists Helping Artists* (AHA)

AHA is an online radio show about selling art online. All the shows have been recorded, so you can browse the archives and listen to old shows based on subject(s) you're interested in. I know a lot of artists who listen to them while they paint, which I think is brilliant!

Read a Book

I recommend *I'd Rather Be in the Studio* by Allison Stanfield.

Hire a Consultant

Allison Stanfield also happens to be an art consultant for hire, as is Leslie Saeta, the voice of *Artists Helping Artists*. If you have questions, or even just need a motivator to keep you on track, I would highly recommend either. You can also Google other art consultants.

Commit

My last bit of advice, but possibly the most important (second to making buying easy, of course) is to commit to this project. Make it a priority. Schedule time, not just to paint, but to market and promote yourself too.

I know I already said this, but don't plan to "give it a month" and then give up when nothing happens. Give it a year. Or two. Or more.

If you're posting to a blog, post as often as possible! My personal goal is to post five days a week, but I try never to let a week pass by without posting *something*, even if I am sick, blocked, or out of town. Oh, and paint as often as possible too (did I already say that?)!

Stay Focused

Keep your blog focused specifically on art. If you have other interests you want to post about, start a separate blog for that. You can link from one to the other in case there are some fans who are interested in both, but don't include two interests on one blog.

Most of all, love your art! If you love what you do, it will be great and people will notice! Happy painting!

Index